D1166390

When I started working on this book I didn't expect how much it would change my life over the next six months. Imagine getting about 30 emails and an average of 8 parcels of new dope stuff from all over the world each day. Despite many long nights of hard work and little sleep I still found great pleasure in doing it! During the process I met a lot of nice people who supported and motivated me, even though I might drove them nuts with all my emails and questions.

Actually, on this page I planned to have a big collage of the various emails I received during the making of. Reactions, criticism, discussions, ideas - it would have been a quite interesting collage. I already worked on it but unfortunately my computer broke down just one week before the book was finished and the photoshop-file & all my emails-addresses got lost. Some very nice photos from New Zealand were gone, too. Fortunately, the backup of the layout file was still there, otherwise you wouldn't be holding this book in your hands.

I would like to use this opportunity to thank all the contributors and pay my respect to the various artists shown here. Also a big thank you to the people who helped me realise this book.

It's done! Enjoy!

Christian

THANKS TO:
ALL THE ARTIST SHOWN IN THIS BOOK FOR THEIR GREAT SUPPORT (SORRY FOR THE MANY EMAILS), ESPECIALLY:
D-FACE (GREAT INTRO!) & STOLENSPACE, EKO FROM EKOSYSTEM, ABOVE (THANKS FOR ENCOURAGING ME IN MY PROJECTS!), FONT, INVADER, FLYING FORTRESS, DOM AT STICKERNATION, THE STICKERWAR-POSSE, MARC AT WOOSTER COLLECTIVE, PEZ (SEE YOU IN BCN), ZOSEN, RONZO, FINDERS KEEPERS, LUCAS, POCH (SORRY FOR SO MANY EMAILS), PRISM FROM STENCILRE-VOLUTION, VINNIE RAY, SWOON, STAK, FISH, SUPAKITCH, TOFER, WEARESHIT, MEAT LOVE, MAMBO, ZEVS, FLOWER GUY, EMKA; THE PLUG, VIAGRAFIK, THE LONDON POLICE, BURNCREW, ASKEW, STAIN & SCOUT (GREAT PACKAGE!), SOCEY & MAGIC, OLSEN, KINSEY, SPACE 3, KAWS (IT'S A PITY YOU DECIDED TO BE NOT IN THE BOOK, THE STUFF YOU SENT WAS GREAT!)
ALSO BIG THANK YOU GOES OUT TO: VANESSA (FOR THE MOTIVATION & HELP), JOSEPH FROM BEAUTIFUL DAYS, NICK (GET A BIG MARKER!), MELANIE, JÖRN & KRIXL FOR MAKING THIS BOOK POSSIBLE, MICHAEL REINBOTH AT COMPOST-RECORDS & ALL MUSICIANS ON THE BONUS CD, FLORIAN KELLER FOR THE GREAT MIX, ANDY AT NITEFLITE NEW MEDIA, HESSENMOB SKATEBO-ARDS, CHRIS AT MONO DESIGN LONDON, MY CLIENTS FOR THEIR PATIENCE, THE FANTASTIK PLASTIKS, DAVID WALKER, GRAVIS, MY FAMILY & FRIENDS & MOGLY.
THANK YOU ALSO TO EVERYONE I FORGOT.
THIS BOOK IS DEDICATED TO MOM AND DAD.

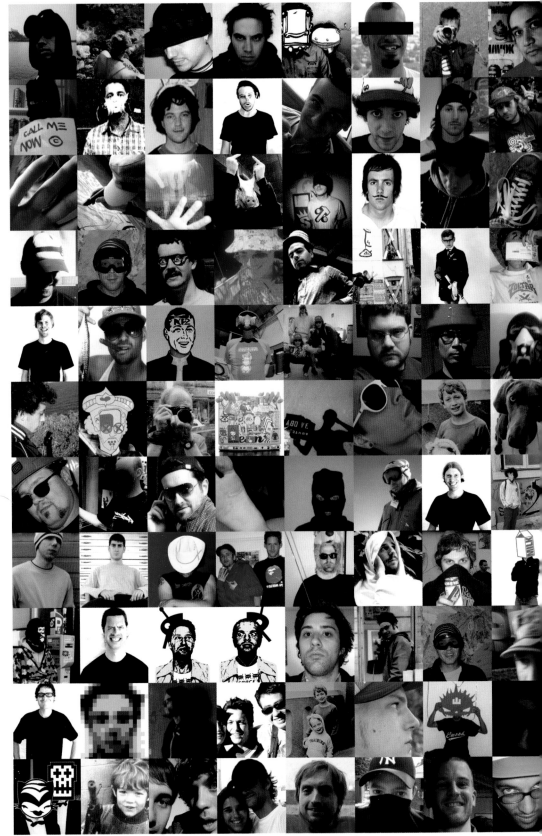

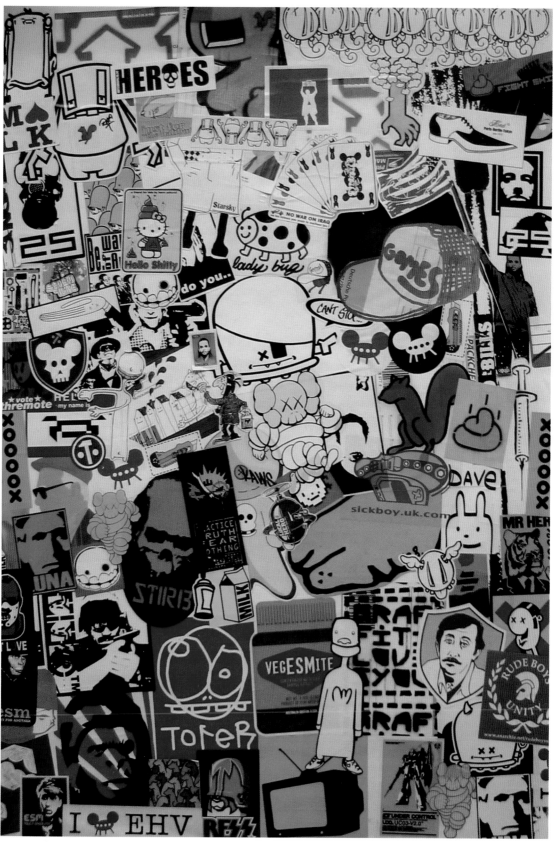

CONTENT

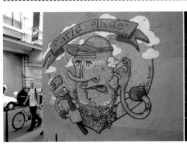 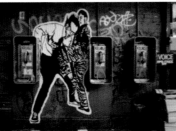 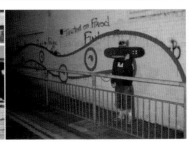

l-r: **ARTIST:** ALEXONE > **COUNTRY:** PARIS.FRA | **ARTIST:** WKINTERACT > **COUNTRY:** NEW YORK.USA | **ARTIST:** DAVE THE CHIMP > **COUNTRY:** LONDON.UK

Publikat Verlag 09.2003 info@publikat.de
1st reprint 12.2003
2nd reprint 07.2004
3rd reprint 02.2005

Concept, art direction and design: Christian Hundertmark | C100
hello@c100studio.com, c100@backyard10.com
http://www.c100studio.com, http://www.backyard10.com/

Gingko Press Inc.
5768 Paradise Drive, Suite J
Corte Madera, CA 94925
.415.924.9615
.415.924.9608
books@gingkopress.com
www.gingkopress.com

I love the title „The Art of Rebellion". I keep thinking of France in 1968 when folks were pissed off and took action to the streets. I think that what's happening now globally. Consciously or Unconsciously artists are trying to shake up the people that are not cruising galleries. Trying to wake up the tired workers, whose minds have been filled with fear and consumption. It's a system of hyper busy lives that can't be bothered with conditions that are "out of their control". I think a fitting statement is......" The stakes are too high for politics to be a spectator sport." I don't know who first said it, but it's a good one...
Vinnie Ray, New York.USA

l-r: **ARTIST:** VINNIE RAY > **COUNTRY:** NEW YORK.USA | **ARTIST:** EL TONO > **COUNTRY:** LIVERPOOL.UK | **ARTIST:** UNKNOWN > **COUNTRY:** MUNICH.GER

INTRO

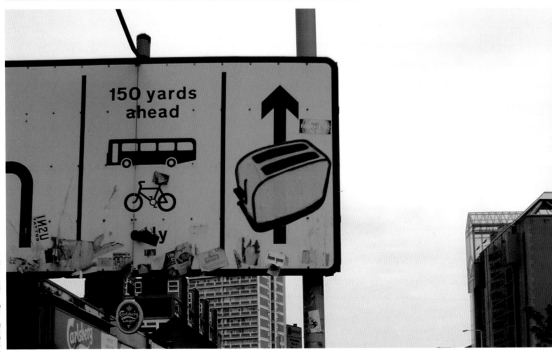

ARTIST: TOASTERS > COUNTRY: LONDON.UK

T
H
E

A
R
T

O
F

R
E
B
E
L
L
I
O
N

Street art, Post Graf, Urban Art- call it what you like, in it's raw essence it's all about leaving your mark. A trace of existence, to taunt or humour the public as well as a liberating F*** You to the powers that deem our work vandalism.

It's not that it can't be viewed as vandalism, but in my mind, every sticker, every tag seen on the street has artistic merit; be it the sprayed flick or a marker drip on a letter or even the illustration style of a particular sticker bomber. Beauty is in the eye of the beholder and there is an aesthetic value and a passion sensed in each piece of work that's up, flick through the pages of this book and you'll see what I mean. If the work was taken out of its urban context, placed on a canvas, given a hefty price tag and hung up in a gallery, it's likely those same people that viewed it as vandalism would see it as art. Although to take the work out of its urban context means the work nearly always loses something in transition, part of the creativity is how it integrates within the environment, the chosen spot which gives it the finishing touch... There is something missing like the interaction and conflict of the work in location. The smack between the eyes of an amazing

ARTIST: ZEVS > COUNTRY: PARIS.FRA

MY FIRST EXPERIENCE OF GRAFFI-
TI WAS DRAWING ON MY PARENTS'
WALL WITH A CRAYON, AGED 8.
I KNEW IT WAS WRONG BUT IT SEE-
MED SO MUCH MORE EXCITING
THAN THE COLOURING BOOKS
THAT I KNEW I COULD DRAW IN.
D-Face, London.UK

THE ART OF REBELLION

reach, the build up of tags on a shutter or the laye-
ring of stickers on the back of a street sign. Each
mark is a reminder to those visually aware enough
to notice that we were here as well as a code to
other artists that passed through and how fresh the
work is when that journey took place. Only the initi-
ated know to whom these pseudonyms belong to.

My first experience of graffiti was drawing on my
parents' wall with a crayon, aged 8. I knew it was
wrong but it seemed so much more exciting than the
colouring books that I knew I could draw in. A few
years on I discovered the book Subway Art, it was
an eye candy binge of pick, mix colours and flavours
for a kid that had been starving hungry. See, I grew
up on a diet of skateboarding, cartoons and cereal
stickers collecting them and swapping them. It was
then that the spark leapt and the connection bet-
ween my graffiti dabbling, a love of cartoons and an
appetite for stickers that D*Face was born.
A series of disfunctional characters for a disfunctio-
nal generation that could be released into the urban
environment through an arsenal of techniques, from
stickers, hand drawing, painting to over sized

pasted posters. I constantly question what myself
and others do, why we take time, lots of energy and
great risks in putting our work into the public
domain. This normally occurs when I'm lying on a
rooftop waiting for the police to drive by in order to
put up some work. But it soon becomes clear when
you flick through the pages of this book and when
you get to meet the great people behind this work,
love it or hate it you have to admire it.
Keep on keeping on.

Peace.
D-Face

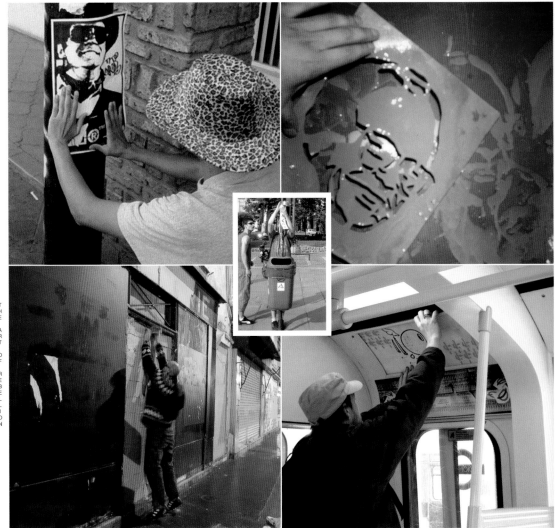

clockwise: **ARTIST:** W/REMOTE > **COUNTRY:** ST.PAUL.USA I **ARTIST:** ACAMONCHI > **COUNTRY:** SAN DIEGO.USA I **ARTIST:** D-FACE > **COUNTRY:** LONDON.UK I **ARTIST:** JACE > **COUNTRY:** PARIS.FRA I **ARTIST:** EMKA > **COUNTRY:** BERGAMO.I

„IT WAS ABOUT 4:30 AT NIGHT AND I WAS WALKING AROUND IN THE 2ND ARRONDISSEMENT NEAR THE OPERA HOUSE. I HAD ABOUT 20 WOODEN ARROWS IN MY BACK PACK THAT I WAS PUTTING UP IN THE AREA. ALONG WITH ME WERE BOTH OF MY 6 FOOT POLES THAT I USED TO ATTACH THE ARROWS SO HIGH TO THE PARISIAN WALLS. I'M WALKING DOWN THE BARE STREET AT A FACE PACE. THERE ARE JUST A FEW OTHER PEOPLE OUT AT THIS TIME. TAXI'S AND HOMELESS PEOPLE. NO ONE ELSE. I AM WALKING ON THE SIDEWALK AGAINST TRAFFIC(ON THE LEFT SIDE) I SEE COMING TOWARDS ME A COP CAR DRIVING REALLY SLOW. THE COP CAR PASSES ME AND THEN HITS THE BRAKES AND DOES IN REVERSE BACK TO WHERE I AM. INSIDE THE COP CAR WAS SOMETHING THAT I HAD NEVER SEEN BEFORE. THERE WERE FOUR COPS IN ONE LITTLE CAR. THREE GUYS AND A LADY. THEY START YELLING AT ME AND TELL ME TO COME CLOSER TO THE CAR. I SPEAK FRENCH BUT DECIDE TO PLAY THE "STUPID AMERICAN" PART AND PRETENT THAT I DONT UNDERSTAND THEM. "WHAT?" I DONT SPEAK FRENCH. WITH THE COPS BROKEN ENGLISH HE ASKS ME WHAT I AM DOING OUT AT THIS TIME OF NIGHT, AND WHAT AM I DOING WITH THESE TWO 6 FOOT POLES? I TOLD THEM THAT I WAS PLAYING MY "GUITAR" AT A CLUB AND THAT I WAS WALKING HOME. ONE OF THE COPS LOOKED AT ME AND SAYED AGAIN IN HIS BROKEN ENGLISH, "GUITAR OF WHAT?" I THEN FLIPPED OVER ONE OF THE POLES OVER TO MEET THE OTHER, AND AM SLIDING THEM TOGETHER UP AND DOWN.I TOLD THEM THAT IT WAS A MAKESHIFT GUITAR THAT I HAD INVENTED. I MIMICKED PLAYING THE GUITAR SLIDING THE POLES UP AND DOWN. THE COP WAS A LITTLE CONFUSED AND ASKED ME WHERE WERE MY GUITAR STRINGS? I TOLD HIM THAT THEY BROKE WHILE I WAS PLAYING AT THE CLUB AND HAD SINCE THROWN THEM OUT. DURING THIS WHOLE TIME I'M STILL PRETENDING TO PLAY THIS "GUITAR." THEY WERE TALKING ABOUT ME IN FRENCH, BECAUSE THEY THOUGHT THAT I DID NOT UNDERSTAND THEM. "IL EST FOU. CE N'EST RIEN! ALLEZ, ON CONTINUE." (HE'S CRAZY, ITS OF NO IMPORTANCE, LETS KEEP GOING) THE COPS THEN APPOLOGIZED AND TOOK OFF DOWN THE STREET. I WATCHED THEM LEAVE AND STARTED TO FINISH THE REST OF THE ARROWS.
BEFORE THE NIGHT WAS OVER I STUCK THEM ALL UP."
Above^, San Francisco.USA

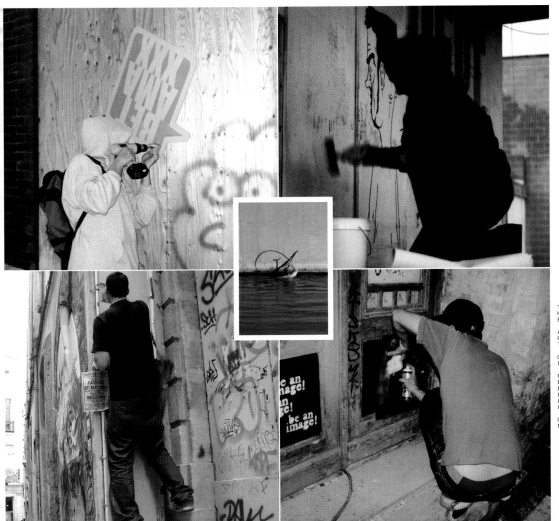

clockwise: **ARTIST:** BETAMAXXX > **COUNTRY:** FINDHOVEN.NL I **ARTIST:** KINSEY > **COUNTRY:** LOS ANGELES.USA I **ARTIST:** BILD > **COUNTRY:** BERLIN.GER I **ARTIST:** SUPAKITCH > **COUNTRY:** MONTPELLIER.FRA I **ARTIST:** FISH > **COUNTRY:** VIENNA.A

CAN YOU DESCRIBE THE FEELING YOU GET WHEN PASTING UP A POSTER IN THE MIDDLE OF A DOWNTOWN BUSY INTERSECTION FOR ALL THE WORLD TO SEE?
„LIKE THAT FIRST BITE ON AN EMPTY STOMACH. I LOVE THE SMELL OF PASTE. IT GIVES ME A RUSH. I FEEL SO RELAXED WHEN I GO OUT BOMBING. I GUESS KNOWING THE EFFECT IT WILL HAVE KEEPS ME GOING AS WELL AND KNOWING I'M USING MY PIECE OF THE PUBLIC SPACE. I LOVE THE QUIET OF NIGHT, THE EMPTY STREETS. LA IS A DIFFERENT WORLD WHEN IT SLEEPS."
Dave Kinsey, Los Angeles.USA

„ONE TIME I WAS PUTTING UP SOME STREET SCULPTURES AND A POLICE CAR PULLED SLOWLY TO FOLLOW ME AS I WAL-KED ALONG THE STREET. I HAD ALREADY GLUED ABOUT 4 PIECES AND WAS CARRYING A BOX WITH 6 OTHERS. TRYING NOT TO LOOK SUSPICIOUS I STARTED PRETENDING TO SEARCH THROUGH THE BOX WITH MY HEAD DOWN AS I WALKED ALONG. UNFORTUNATELY, I COULD SEE WHERE I WAS GOING AS I WAS STILL CONCENTRATING ON THE POLICE CAR FOLLOWING AND I TRIPPED OVER A LARGE PLANT STAND PLACED ON THE FOOTPATH BY THE COUNCIL. I FELL,L TWISTED MY ANKLE, GRA-ZED MY LEG AND BROKE THREE OF THE SCULPTURES IN THE BOX. FROM THE GROUND I LOOKED UP TO SEE THE PLOICE CAR DRIVE OFF LAUGHING. I WENT BACK THE NEXT NIGHT WITH THE FIXED SCULPTURES AND A SHARP EYE FOR ANYTHING I MIGHT TRIP OVER."
ECCE, Sidney.AU

ARTIST: THE LONDON POLICE > **COUNTRY:** MBARCELONA.ESP

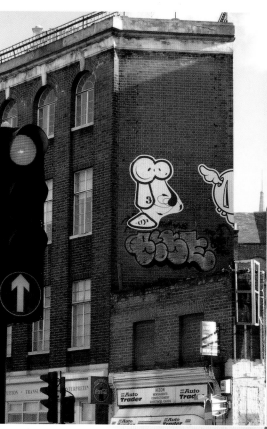

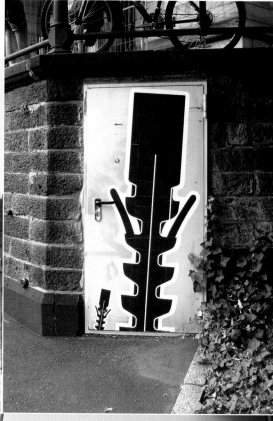

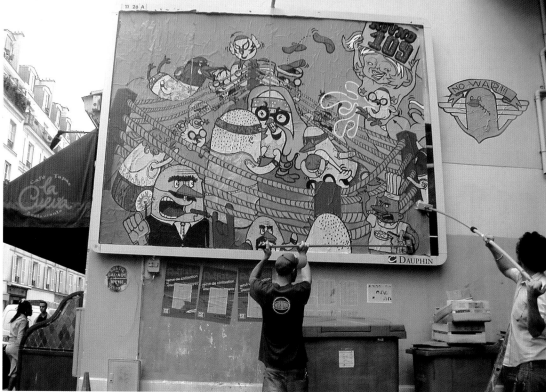

clockwise: **ARTISTS:** THE LONDON POLICE, D-FACE > **COUNTRY:** LONDON.UK I **ARTIST:** VIAGRAFIK > **COUNTRY:** WIESBADEN.GER I **ARTIST:** ALEXONE > **COUNTRY:** PARIS.FRA

--

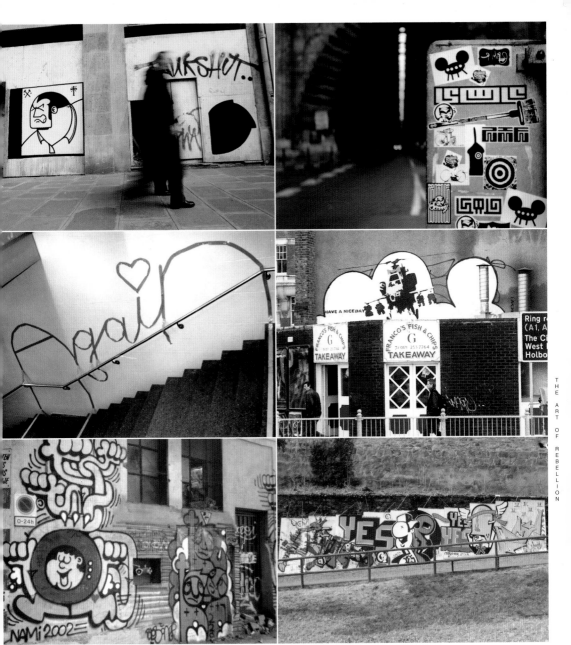

1st. row: **ARTIST:** HNT, STAK > **COUNTRY:** PARIS.FRA **I ARTIST:** SOL CREW, SPACE3 > **COUNTRY:** BUDAPEST.HU
2nd. row: **ARTIST:** UNIVERSE THE LITTLE DOG > **COUNTRY:** FRANKFURT.GER **I ARTIST:** BANKSY > **COUNTRY:** LONDON.UK
3rd. row: **ARTIST:** LA MANO, BLOB > **COUNTRY:** BARCELONA.ESP **I ARTIST:** SCRIPT, EMKA, FLYING FORTRESS, CROOKED INDUSTRIES & RICO > **COUNTRY:** BERGAMO.I

--

THE MOST FUNNY EXPERIENCE I'VE HAD WAS PAINTING IN INDIA, IN THE FISHERMAN'S VILLAGE OF PULICAT,
IN 1993, WITH LA FORCE ALPHABETICK AND CALLIGRAPHER ANAND. NO WITHEMAN CAME THERE FOR 5 YEARS.
THE KIDS WERE MAD ABOUT US, THE SMALLER ONES WERE WATCHIN US AS E.T.'S! THEY TOUCHED OUR SKIN AND "OH,
BEAUTIFUL... . WE PAINTED THE WALL OF THE SCHOOL AND CHURCH OF THE VILLAGE. ALL THE VILLAGE (14000 PEOPLE)
WERE WATCHING US. THEY ALL WANTED TO TALK, INVITE US TO THEIR HOMES, THAT WAS REALLY STRONG. WE WERE
LIVING IN THE CHURCH, GOING FOR DINNER AT THE COVENT, PLAYIN' WITH KIDS FROM THE SCHOOL. WE TEACHED THE
KIDS TO SING RAGGAMUFFIN. THEIR VILLAGE IS IN A MASSIVE BEACH AND IT'S PARADISE.
I NEVER DID A PIECE THAT MAKE THE PEOPLE FEEL THAT HAPPY AND THANKFUL.
Mambo, Paris.FRA

--

London.UK

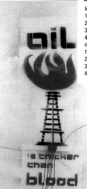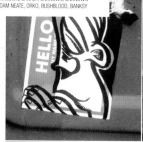

THE ART OF REBELLION

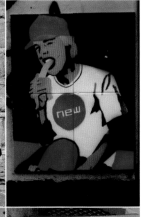
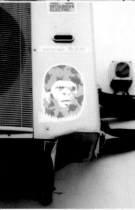

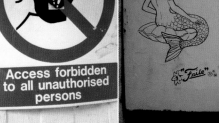
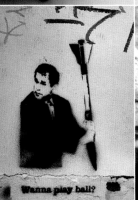
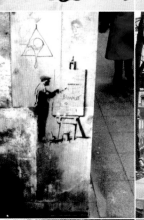
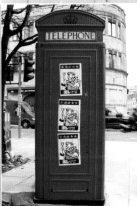

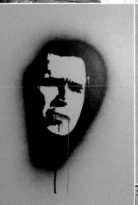

THE ART OF REBELLION

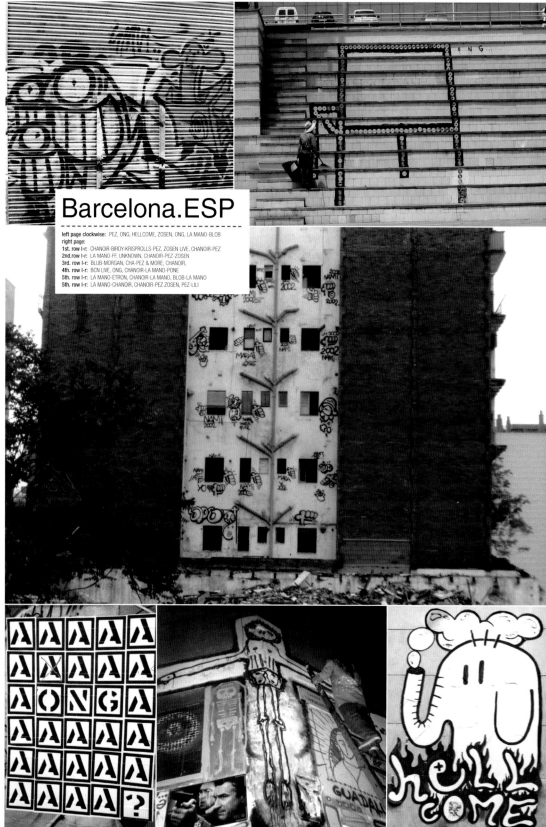

Barcelona.ESP

left page clockwise: PEZ, ONG, HELLCOME, ZOSEN, ONG, LA MANO-BLOB
right page:
1st. row l-r: CHANOIR-BIRDY-KRISPROLLS-PEZ, ZOSEN LIVE, CHANOIR-PEZ
2nd.row l-r: LA MANO-FF, UNKNOWN, CHANOIR-PEZ-ZOSEN
3rd. row l-r: BLUB-MORGAN, CHA-PEZ & MORE, CHANOIR,
4th. row l-r: BCN LIVE, ONG, CHANOIR-LA MANO-PONE
5th. row l-r: LA MANO-ETRON, CHANOIR-LA MANO, BLOB-LA MANO
5th. row l-r: LA MANO-CHANOIR, CHANOIR-PEZ ZOSEN, PEZ-LILI

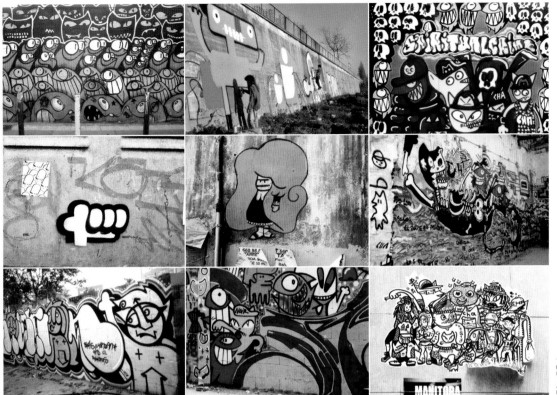

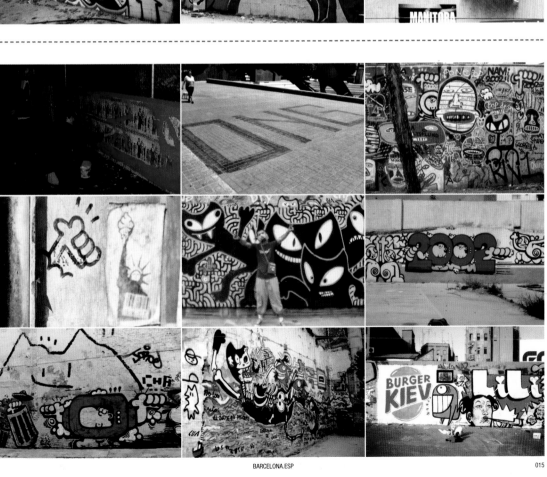

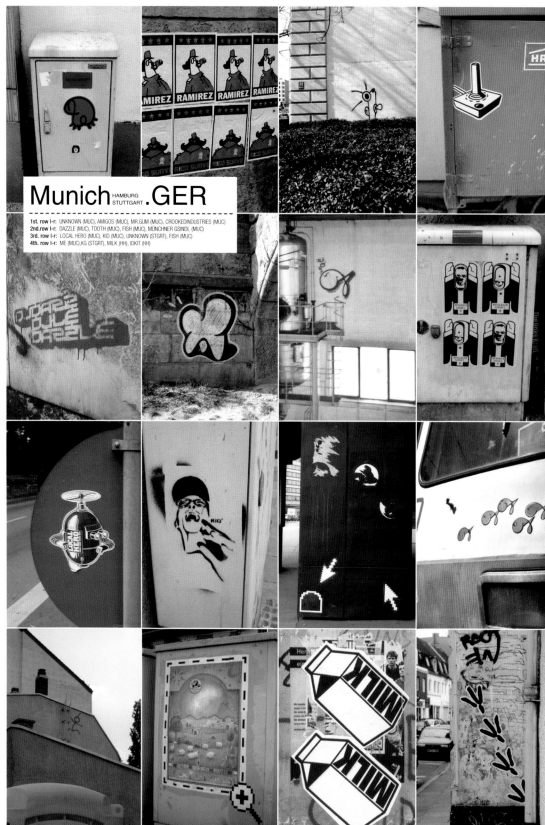

Munich HAMBURG STUTTGART .GER

1st. row l-r: UNKNOWN (MUC), AMIGOS (MUC), MR.GUM (MUC), CROOKEDINDUSTRIES (MUC)
2nd.row l-r: DAZZLE (MUC), TOOTH (MUC), FISH (MUC), MÜNCHNER GSINDL (MUC)
3rd. row l-r: LOCAL HERO (MUC), KID (MUC), UNKNOWN (STGRT), FISH (MUC)
4th. row l-r: ME (MUC),KG (STGRT), MILK (HH), IDKIT (HH)

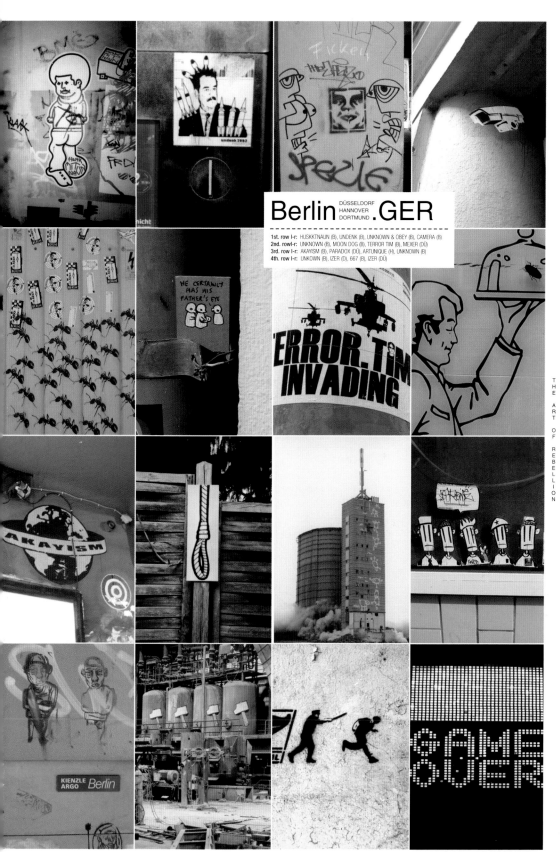

Berlin .GER
DÜSSELDORF
HANNOVER
DORTMUND

1st. row l-r: HUSKKTNAUN (B), UNDENK (B), UNKNOWN & OBEY (B), CAMERA (B)
2nd. rowl-r: UNKNOWN (B), MOON DOG (B), TERROR TIM (B), MEXER (DÜ)
3rd. row l-r: AKAYISM (B), PARADOX (DÜ), ARTUNIQUE (H), UNKNOWN (B)
4th. row l-r: UNKOWN (B), IZER (D), 667 (B), IZER (DÜ)

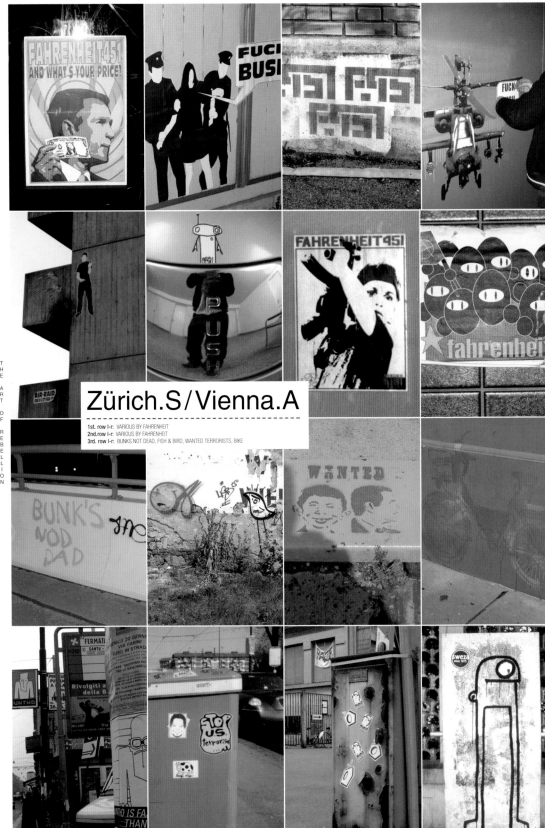

THE ART OF REBELLION

Zürich.S/Vienna.A

1st. row l-r: VARIOUS BY FAHRENHEIT
2nd.row l-r: VARIOUS BY FAHRENHEIT
3rd. row l-r: BUNKS NOT DEAD, FISH & BIRD, WANTED TERRORISTS, BIKE

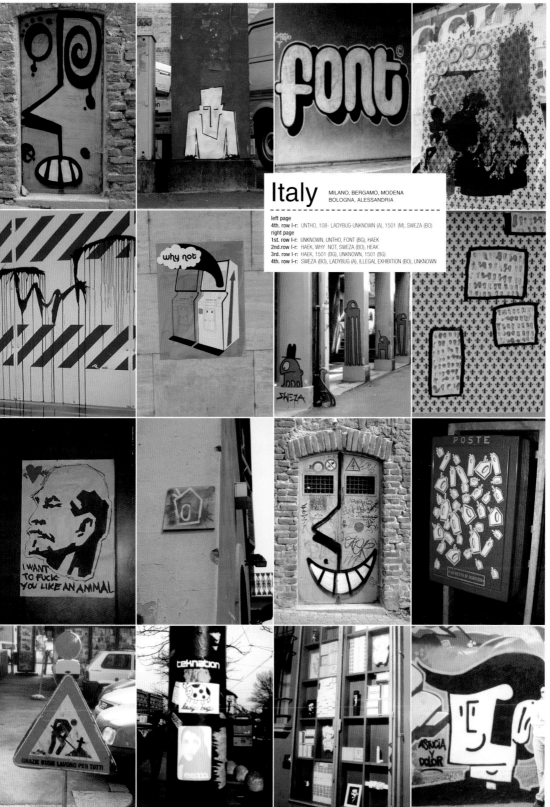

Italy

MILANO, BERGAMO, MODENA
BOLOGNA, ALESSANDRIA

--

left page
4th. row l-r: UNTHO, 108- LADYBUG-UNKNOWN (A), 1501 (M), SWEZA (BO)
right page
1st. row l-r: UNKNOWN, UNTHO, FONT (BG), HAEK
2nd.row l-r: HAEK, WHY NOT, SWEZA (BO), HEAK
3rd. row l-r: HAEK, 1501 (BG), UNKNOWN, 1501 (BG)
4th. row l-r: SWEZA (BO), LADYBUG (A), ILLEGAL EXHIBITION (BO), UNKNOWN

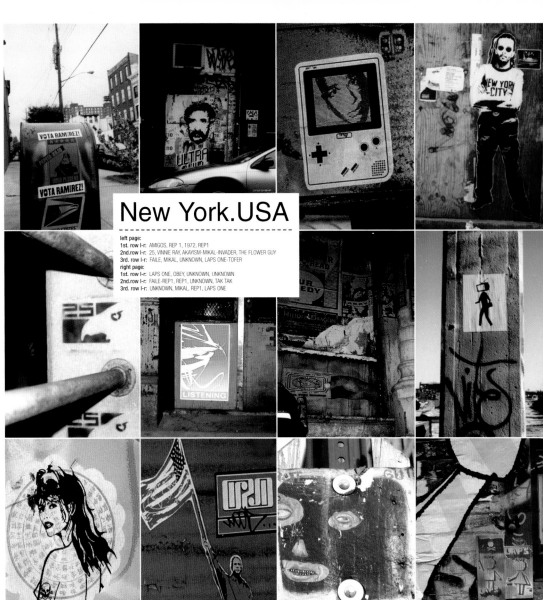

New York.USA

left page:
1st. row l-r: AMIGOS, REP 1, 1972, REP1
2nd.row l-r: 25, VINNIE RAY, AKAYISM-MIKAL-INVADER, THE FLOWER GUY
3rd. row l-r: FAILE, MIKAL, UNKNOWN, LAPS ONE-TOFER
right page:
1st. row l-r: LAPS ONE, OBEY, UNKNOWN, UNKNOWN
2nd.row l-r: FAILE-REP1, REP1, UNKNOWN, TAK TAK
3rd. row l-r: UNKNOWN, MIKAL, REP1, LAPS ONE

<div style="writing-mode: vertical">T H E A R T O F R E B E L L I O N</div>

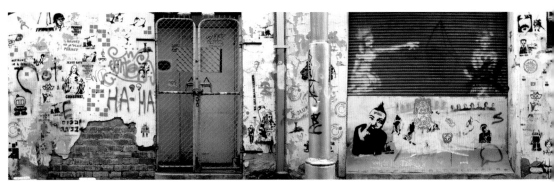

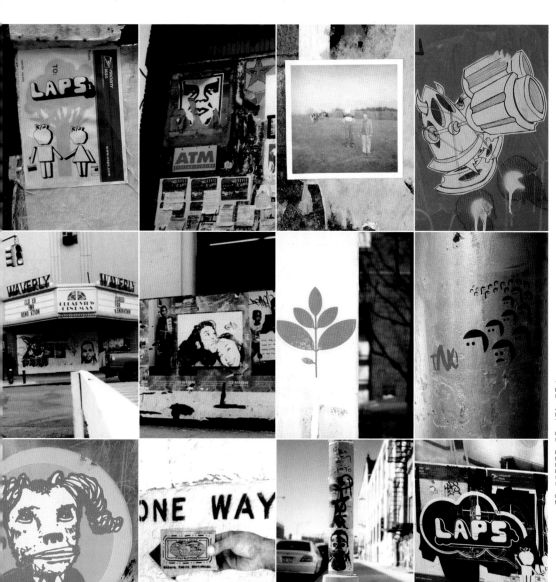

below: **ARTISTS:** VARIOUS > **COUNTRY:** CARLTON.USA

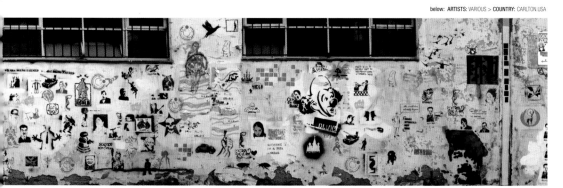

Mr.Andre
Paris.FRA

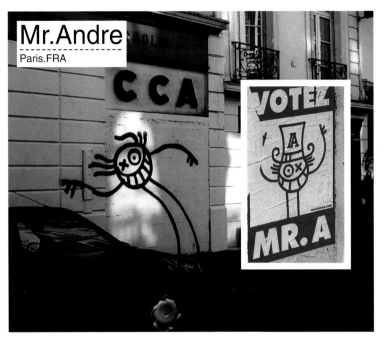

Mysterious AI
London.UK

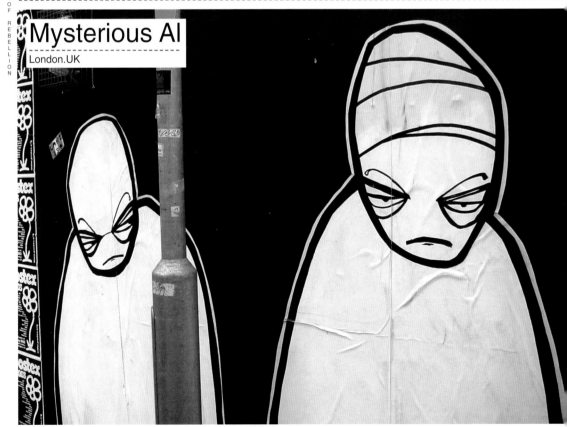

http://www.mysteriousal.com/

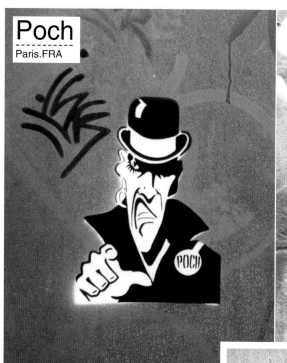

Name: POCH. (patrice)

Age: 30 years old

Hometown: PARIS but now RENNES since two years.

Cities where to find your arts?

for 2003 : Rennes. Toulouse. Barcelone. Genes. Rome. Modene (Italie)

How did you come up with your character?....

it's just an evolution of my work... I'vn't got special message.

How did you get into street art and when?

I listen punk and oi music since 86 and in 88 I began to do stencils in the streets then in 89 I began to do graffiti more tradihonnal. To come back at the end of the 90's at stencilk. posters. latex paint in the street...

Other street arhrts you respect?

Blek le rat cause he's one of the first who did stencils in Paris and his work mark me in the middle of the 80's

BANDO and SHOE for them works and letters
SHUN cause he was my partner and his work is really crazy

Other interests:

MARK RYDEN. Frank Margerin. Egon SCHIELE

Inspirations?

a lot of things: All the stuff from punk music and ska like flyers, cover's records, old posters graphism from the 60's. 70's. 80's. Tatouages and Hotrad cultures...

Your favorite music?

punk 80. oi music . mods . ska . skinhead reggae . oldschool rap < 91

Did you ever get in trouble...?

no trouble... nothing really important!

What do you think is the future of street Art.?

Je pense qu'il y aura toujours une forme d'art dans la rue. depuis l'essor qu'a connu le graffiti au etats Unis. jusqu'a son interpretation en Europe. le street Art peut que continuer a exister avec ses hauts et ses bas. Cela represente beaucoup trop de gens dans le monde pour s'arrêter du jour au lendemain...

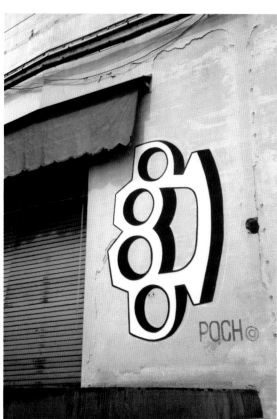

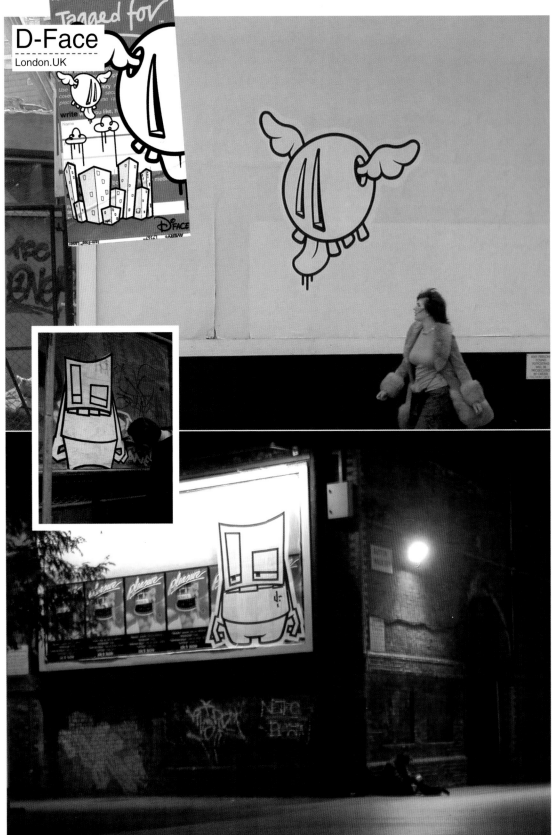

D-Face
London.UK

THE ART OF REBELLION

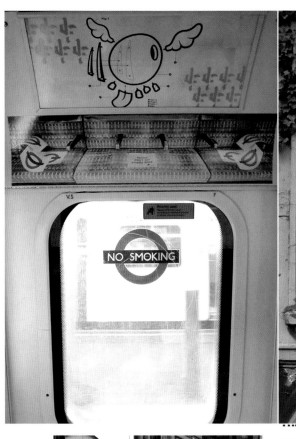

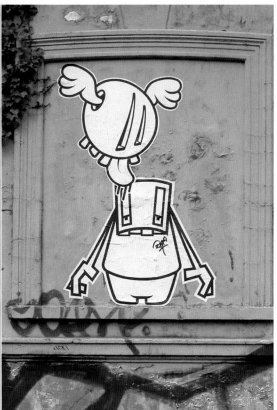

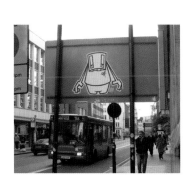

>> Name: DFACE ← ⫤ Ḏ FACE 🐦 DAFACE@STOLENSPACE

>> Age: UNKNOWN.

>> Hometown: LONDON.

>> Cities where to find your art: AMSTERDAM, BARCELONA, LONDON, NEW YORK, PARIS.

>> How did you come up with your character? Do you have a special message? I WANTED TO CREATE SOME FUCKED UP DISNEY CHARACTERS, WHO LIKE TAGS AND DRIPPY PAINT AND HANGING OUT AT THEIR FAVOURITE CITY SPOTS; LAMPPOSTS, ELECTRICITY BOXES ... All FREE TO SPEAK THEIR MIND !!

>> How did you get into street art and when? I NEEDED TO BREAK FREE OF THE CREATIVE RESTRICTIONS THAT SURROUND ME, TO CREATE A PIECE OF VISUAL DISTURBANCE, GETTING PEOPLE TO QUESTION THE CHARACTER, ITS PLACEMENT, WHO PUT IT THERE, WHY + WHAT FOR. TO PUT A SMILE ON YOUR FACE OR FROWN ON YOUR FOREHEAD.

>> Other street artists you admire / respect and why? All LIKE MINDS THAT GET UP + OUT. BUT A SPECIAL SHOUT TO: THE LONDON POLICE (P.C.C...) SHEPARD FAIREY, DALEK, ADAM NEATE, CHIMP, YUKE...

>> Other interests: MY GIRLFRIEND !! GRAPHIC DESIGN, TYPOGRAPHY, SKATEBOARDING, MUSIC. All FORMS OF ART.

>> How does a typical day in your life look like? THERE IS NO TYPICAL DAY, BUT EVERY DAY CONSISTS OF THINKING, DRAWING, DOODLING AND DAY DREAMING. THESE ARE CONSISTENT FOR All MY DAYS.

>> Inspirations: OTHER LIKE MINDS, THE STREET, TRAVEL. LOVE.

>> Your favorite music? ANYTHING WITH ENERGY + PASSION. SPECIALLY HIP HOP + PUNK.

>> Did you ever get in trouble as a street artist and what happened? YES IT COMES WITH THE TERRITORY !! I'VE BEEN ARRESTED BY THE TRANSPORT POLICE, VARIOUS POLICE STOP AND GOES. ONLY ... CAUTIONS + RELEASE.

>> What do you think is the future of street-art? Will it increase/decrease? STREET ART IS PROGRESSIVE, NEW MEDIUMS WILL BE EMBRACED BUT THE SAME GOALS WILL ALWAYS PREVAIL - FOR THE INDIVIDUAL TO GET THEIR WORK UP AND NOTICED.

>> 5 Things you couldn't live without and why: LOVE: IT MAKES SENSE OF LIFE. 10 YEAR ADHESIVE VINYL AND A MARKER PEN !!

>> Things you don't like: THE RAIN !! PIGEONS, TIME WASTING + TIME WASTERS. VIOLENCE, SPLINTERS.

>> Any advise? TALK MINUS ACTION EQUALS ZERO. DON'T JUST LOOK SEE. SLEEP IS THE ENEMY.

F!!K SHIT UP. STILL THUGGIN

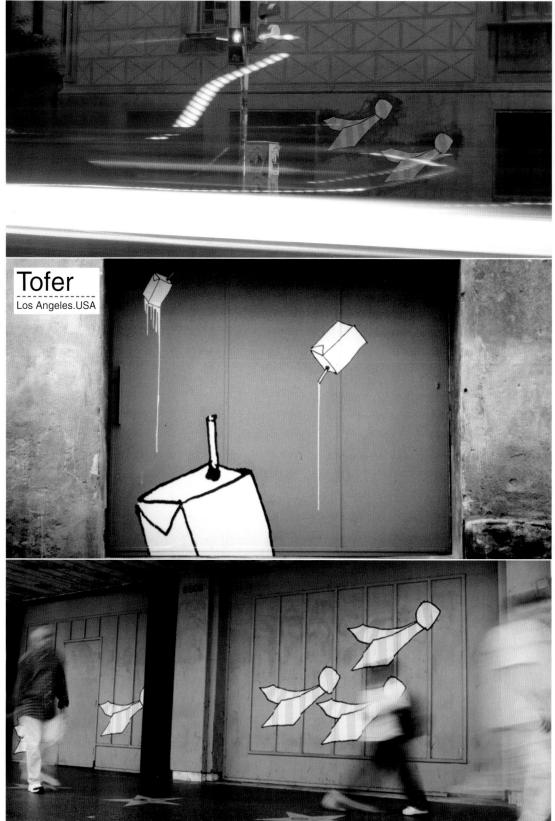

Tofer
Los Angeles.USA

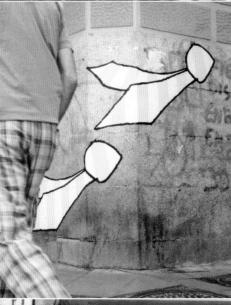

THE ART OF REBELLION

>> Name: **TOFER**

>> Age: **24**

>> Hometown: **LA**

>> Cities where to find your art: **LA, NYC, SF, BARCELONA, MADRID, AMSTERDAM**

>> How did you come up with your character? Do you have a special message?
DOODLING ON THE COMPUTER

>> How did you get into street art and when?
2000

>> Other street artists you admire / respect and why?
BUFFMONSTER, EL TONO, FLOWERGUY, SWOON

>> Other interests:
PAINTING & EATING

>> How does a typical day in your life look like?
BEING PRODUCTIVE

>> Inspirations: ~~MOTIVATION~~ **MOTIVATION**

>> Your favorite music? **ROCK, RAP, HIP-HOP, ELECTRO,** ~~.~~ **... METAL, JAZZ, 80's.**

>> Did you ever get in trouble as a street artist and what happened?
N/A

>> What do you think is the future of street-art? Will it increase/decrease?
IT WILL ALWAYS EXIST

>> 5 Things you couldn't live without and why:
FRIENDS & FAMILY

>> Things you don't like:
NEGATIVITY

>> Any advise?
NEVER GIVE UP!

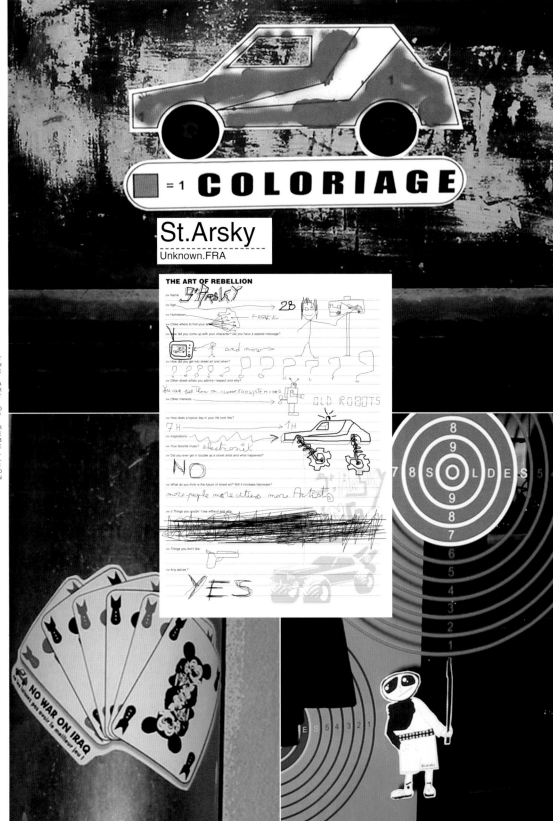

Joystickers
Barcelona.ESP

THE ART OF REBELLION

>> Name: Joystick
>> Age: TEN MONTHS
>> Hometown: BARCELONA
>> Cities where to find your art: BARCELONA / TOLEDO / CUENCA / MADRID
>> How did you come up with your character? Do you have a special message?

SPARKPLUG → THE STARTER

>> How did you get into street art and when?

WITH OUR JOYSTICKERS PROJECT. FEB/03

>> Other street artists you admire / respect and why?

— BANKSY, STARSKY, THE LONDON POLICE, SPACE INVADERS, AIKO,
(THERE ARE LOTS !!!)

>> Other interests:
 PATACONES....

>> How does a typical day in your life look like?

LIKE A COMPUTER SCREEN

>> Inspirations: THE CITY
>> Your favorite music? CURRULAO + BULLERENGUE
>> Did you ever get in trouble as a street artist and what happened?

NEVER....

>> What do you think is the future of street-art? Will it increase/decrease?

IT IS INCREASING RIGHT NOW

>> 5 Things you couldn't live without and why:

WATER + FOOD + AIR + SUN + TIME

>> Things you don't like:

THAT WE NEED PAPERS TO WORK OVER HERE.

>> Any advise?

IF YOU THINK IT'S GOOD.... KEEP IT GOING

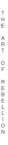

Vinnie Ray
New York.USA

SEARCHING

SEARCHING?

LISTENING

THE ART OF REBELLION

>> Name: Vinnie Ray

>> Age: 33

>> Hometown: Brooklyn

>> Cities where to find your art: NY, LA, Seattle, Tokyo

>> How did you come up with your character? Do you have a special message?
Most Doodles made while on the Phone. Then I assigned them the phrases - Searching, thinking, Expanding, etc

>> How did you get into street art and when?
I did street Performance that turned into the One World Co

>> Other street artists you admire / respect and why? REVS, Flower Guy, Swoon, OBEY. Jenny Holzer

>> Other interests: Music - My Band

>> How does a typical day in your life look like? Computer Screen, Coffee, Cell Phone
The 3 C's

>> Inspirations: Music, Concerts

>> Your favorite music? The kind that takes me somewhere

>> Did you ever get in trouble as a street artist and what happened?
No

>> What do you think is the future of street-art? Will it increase/decrease?
I think the future of Street Art will increase as the amount of Corrupt Corporate/Governments squeeze all of us

>> 5 Things you couldn't live without and why
My wife, she's right here with me. Nature. Books I love having one in my Bag, Internet. My Family + Friends

>> Things you don't like: Apathy

>> Any advise? The Green Party

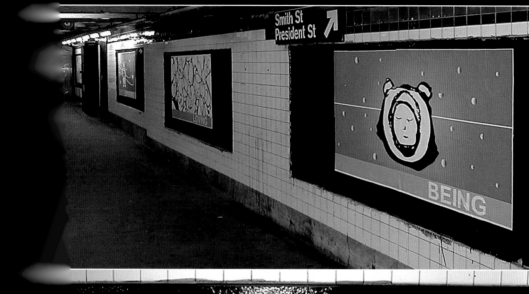

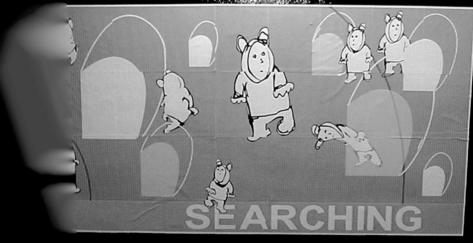

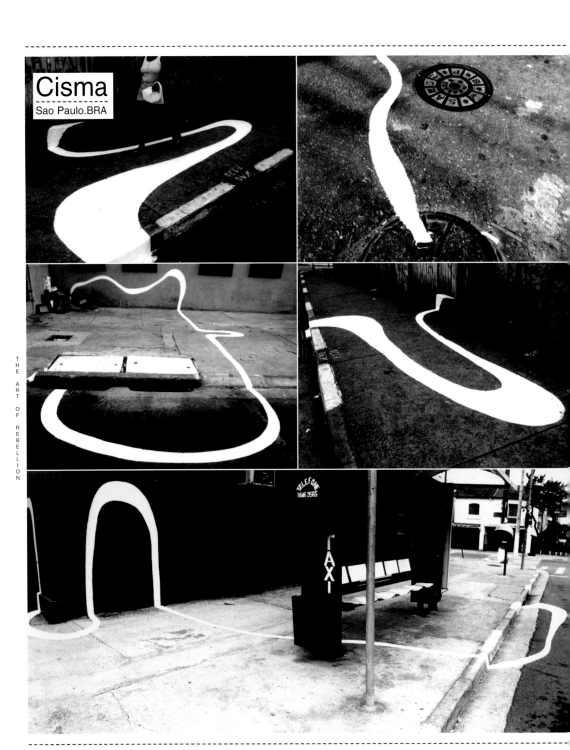

Cisma
Sao Paulo.BRA

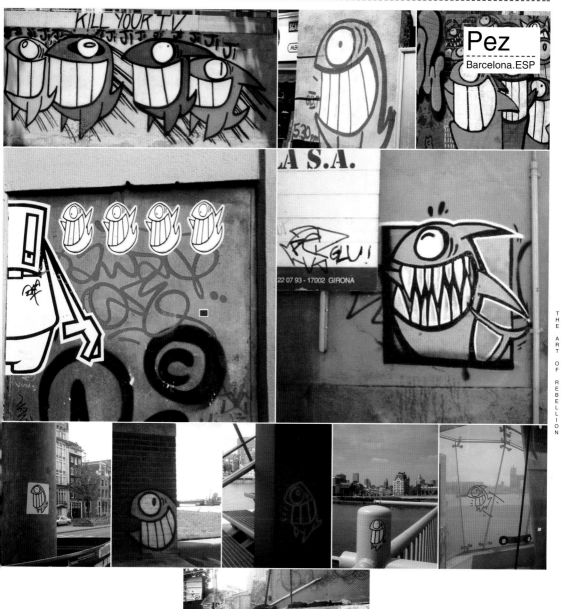

THE ART OF REBELLION

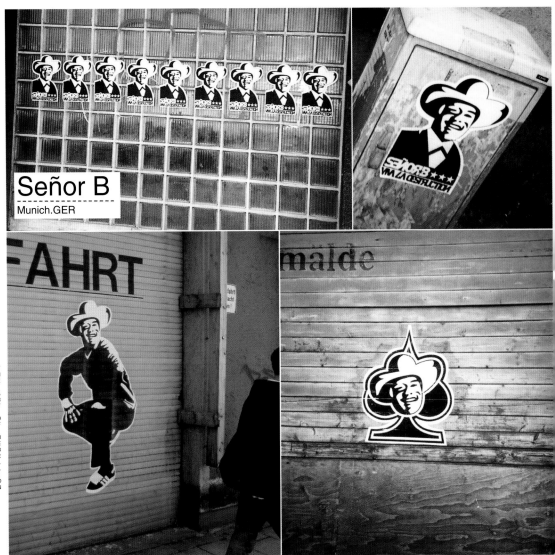

Señor B
- - - - - - - -
Munich.GER

no webaddress

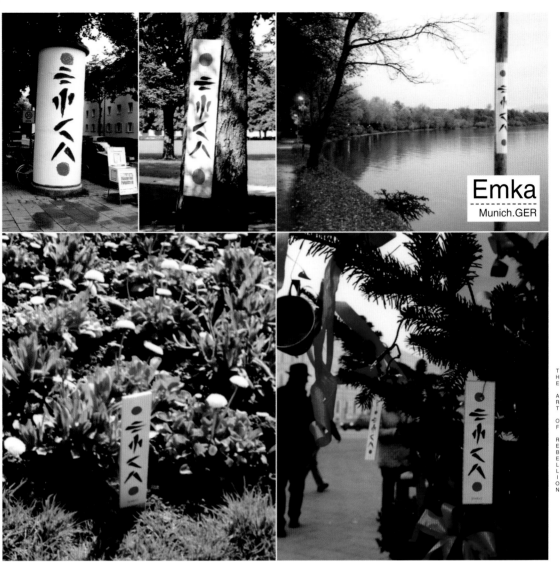

Emka
Munich.GER

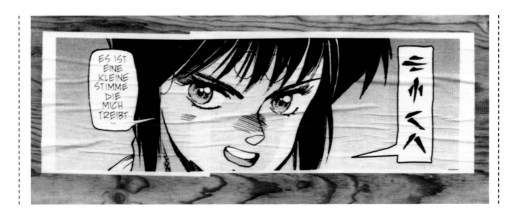

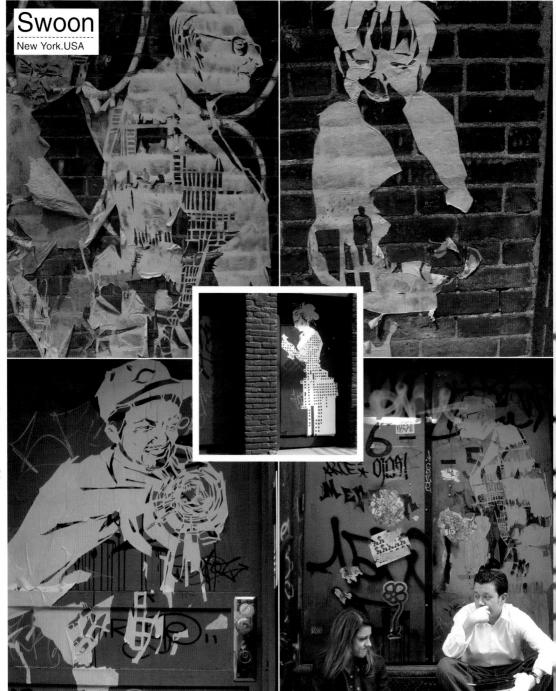

THE ART OF REBELLION

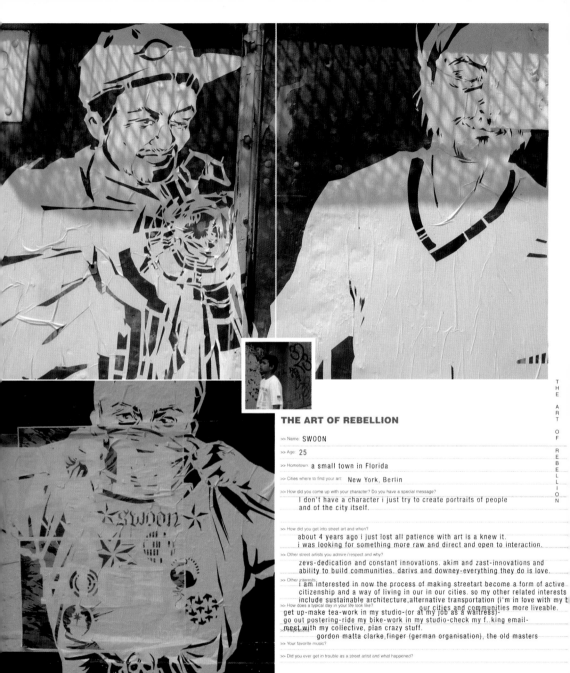

THE ART OF REBELLION

>> Name: SWOON

>> Age: 25

>> Hometown: a small town in Florida

>> Cities where to find your art: New York, Berlin

>> How did you come up with your character? Do you have a special message?

I don't have a character i just try to create portraits of people
and of the city itself.

>> How did you get into street art and when?

about 4 years ago i just lost all patience with art is a knew it.
i was looking for something more raw and direct and open to interaction.

>> Other street artists you admire / respect and why?

zevs-dedication and constant innovations. akim and zast-innovations and
ability to build communities. darivs and downey-everything they do is love.

>> Other interests:

i am interested in now the process of making streetart become a form of active
citizenship and a way of living in our in our cities. so my other related interests
include sustainable architecture, alternative transportation (i'm in love with my b
our cities and communities more liveable.

>> How does a typical day in your life look like?

get up-make tea-work in my studio-(or at my job as a waitress)-
go out postering-ride my bike-work in my studio-check my f..king email-
meet with my collective, plan crazy stuff.

gordon matta clarke, finger (german organisation), the old masters

>> Your favorite music?

>> Did you ever get in trouble as a street artist and what happened?

fingers crossed

>> What do you think is the future of street-art? Will it increase / decrease?

hopefully streetart will continue to increase and hopefully and
involve more people more opinions and more reasons for needing
a visual public commons

>> 5 Things you couldn't live without and why:

>> Things you don't like:

the president of the united states of america

>> Any advise?

don't be afraid to do a little work

Dave Warnke
San Francisco.USA

108
Alessandria.I

THE ART OF REBELLION

>> Name: 108

>> Age: 25

>> Hometown: ALESSANDRIA (ITALY)

>> Cities where to find your art: ALESSANDRIA, MILANO, MODENA, GENOVA, AMSTERDAM, GENEVE, BERLIN, NEW

>> How did you come up with your character? Do you have a special message? AFTER MANY YEARS OF WRIT?
I TRYED TO TAKE OFF LETTERS... I LIKE ABSTRACT AND MINIMAL ST
I THINK THERE IS NO SPECIAL MESSAGE.

>> How did you get into street art and when?
FIRST 90'S I STARTED TO DO GRAFFITI ... IN 99 I STARTED TO DO DIFFERENT THINGS

>> Other street artists you admire / respect and why?
MY FRIENDS PETO AND SUEDE, LADY BUG, G FROM BERLIN, HONET FROM PARIS, DAVE...
I LIKE PEOPLE THAT DOING DIFFERENT STUFF...

>> Other interests: MUSIC, ANY KIND OF ART, UNDERGROUND COMICS ... TOO M
INTERESTS...

>> How does a typical day in your life look like?
I WAKE UP, I WASTE MY TIME FOR ALL THE DAY... I HATE TO WORK,
I'VE NO MONEY

>> Inspirations: TREES, ROOTS, STONES, OCCULT AND PAGAN STUFF... NOTHU

>> Your favorite music? HARDCORE PUNK, EXTREME METAL, GRIND, DARK WAVE;

>> Did you ever get in trouble as a street artist and what happened?
I'M NEVER GET SERIOUSLY IN TROUBLE ... SOME TIMES I HAVE HAD
PROBLEMS AS A WRITER WITH POLICE.

>> What do you think is the future of street-art? Will it increase/decrease?
I THINK STREET ART IN THE LAST TIME IS BECOMING A TREND. I THINK I
FUTURE STREET ART WILL DECREASE... I HOPE THERE WILL BE MO
EXPERIMENTATION ... THE TYPICAL STICKERS/POSTERS/STANCILS STUFF I

>> 5 Things you couldn't live without and why:
MHM... ART, HC/PUNK SHOWS, UNDERGROUND COMICS, THE
MOUNTAINS, FALAFEL.

>> Things you don't like:
FAKE ARTISTS, RAP, MEAT, TYPICAL ITALIAN PEOPLE...

>> Any advise? BE UNDERGROUND AND FUCK THE WORLD!

http://www.davewarnke.com/

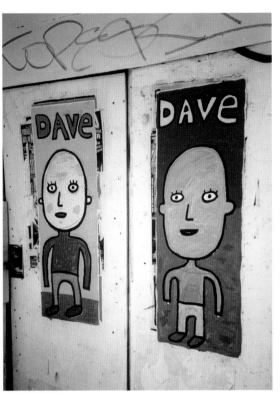

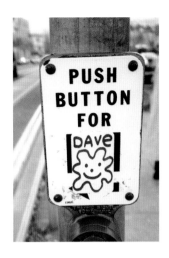

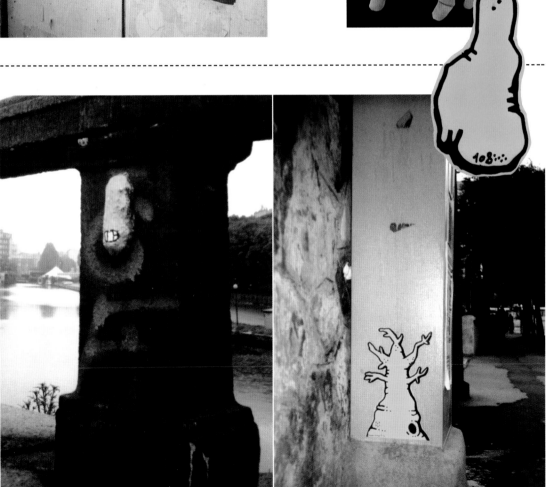

Eko
Unknown.FRA

THE ART OF REBELLION

>> Name: eko

>> Age: 15 IN THE EIGHTIES

>> Hometown: SOUTH WESTERN FRANCE

>> Cities where to find your art: 10 KM AROUND ME

>> How did you come up with your character? Do you have a special message?
A MIX OF PLAYMOBIL™ AND PEZ™.
I'M ALIVE !

>> How did you get into street art and when? I'VE NEVER STARTED. i STILL HAVE
THE FEELING TO DO GRAFFiTi.

>> Other street artists you admire / respect and why? LA MANO / SPACE INVADER / HONET /
SOBRE, JACE, SIXE, CHANOIR, THEY ARE ORIGINAL !

>> Other interests: P2P - ALBUMS FOR CHILDREN - MVSiC - ViDEO -
INTELLECTUAL PROPERTY RIGHTS - ALTERNATIVES TO GLOBALIZATION

>> How does a typical day in your life look like? (NO ORDER) - TAKE A BATH WiTH MY SON -
UPDATE EKOSYSTEM.ORG - WORK & EAT - SLEEP & DRINK - CVT & PASTE POSTERS

>> Inspirations: EVERYTHING AROUND ME.

>> Your favorite music?
CHRONOLOGICAL ORDER = PIXIES - SONIC YOUTH - PUBLIC ENEMY - JEFF MILLS - DAFTPUNK - POLE
80's 90's 00's
THE NEPTUNES

>> Did you ever get in trouble as a street artist and what happened?
i COULD ANSWER YOU, iF i WAS A STREET ARTiST.

>> What do you think is the future of street-art? Will it increase/decrease? I ACTUALLY DON'T MIND.
I DO MY THING TiLL i ENJOY iT !

>> 5 Things you couldn't live without and why: FOOD - WATER - LOVE - FRIENDS - ART
BECAUSE i'M HUMAN.

I ALSO DO NEED SUNSHINE

>> Things you don't like: BVSH FAMILY - TRUCKS - DAViD DOUiLLET - ERNEST ANToiNE SEiLLiERE
MARKETiNG - PROFESSiONAL SPORT - RAiNY SUNDAYZ - MTV - NiKE - MCDONALDS - TOTAL

>> Any advice? THiNGS YOU LiKE = BARCELONA - POP ART - RAP (FROM 87 TO 93) - TEA
1 ST ATARi ViDEO GAMES - MINIMALiSM - MVLHOLLAND DRIVE - THE BiG LEBOWSKY -
PiERRE LA POLiCE - RiNZEN - H5 - DR - CHRiSTELLE - MERLiN

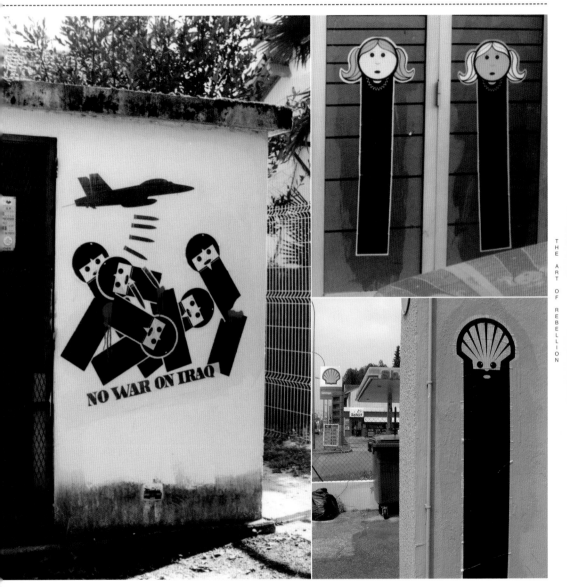

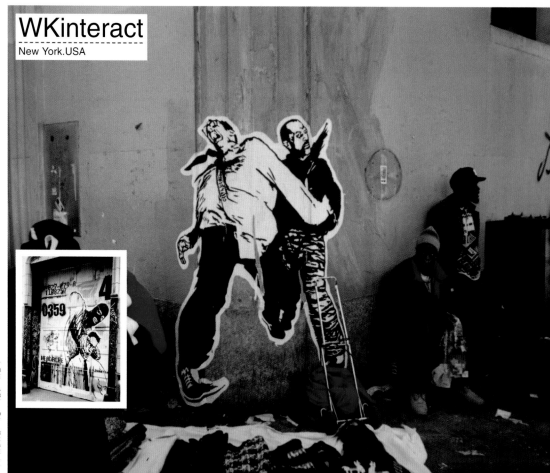

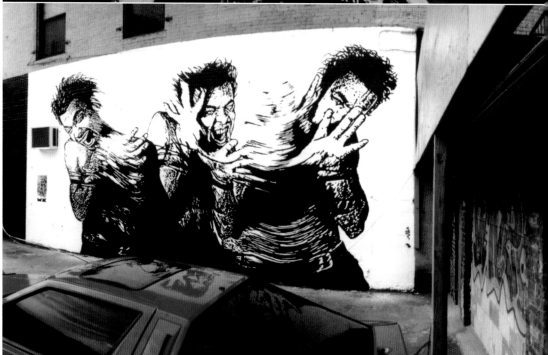

Name: WK INTERACT
Age: 34
Hometown: NYC FROM FRANCE
Cities where to find your art: NYC PARIS SYDNEY US JAPAN
How did you come up with your character? Do you have a special message?
MOTION AND SPEED OF HUMAN
How did you get into street art and when? 16 YEARS AGO
IT'S FREE FOR ANYBODY TO LOOK AT
Other street artists you admire / respect and why: ANYONE
TO CREATE
MAKE TAKE TIME SCULPTURE
Other interests: PHOTOGRAPHIE INGENIOR
MOVIE BOOKING
How does a typical day in your life look like?
BE NEW IDEAS
Inspirations: ANYTHING IN MOTION
Your favorite music? JAZZ
Did you ever get in trouble as a street artist and what happened?
SOMETIME
What do you think is the future of street-art? Will it
IT WILL DEPEND
IN THE NEXT GENERATION
AND WHAT KIND OF TOOL
5 Things you couldn't live without and why:
L AMOUR
DECOUVERT CREER
UN BON REPAS LIBERTE
> Things you don't like:
TIME PASS TO FAST
> Any advise?
KEEP CHALLENGE WK INTERACT
YOURSELF

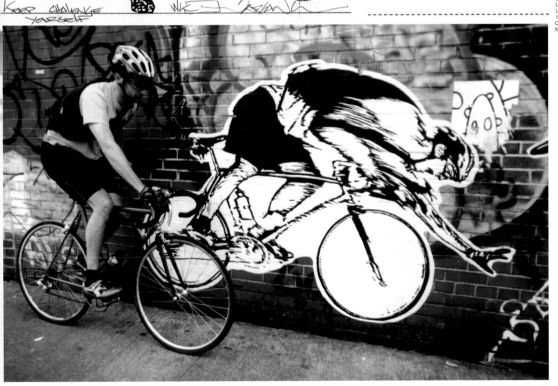

The Plug

Massaly.B

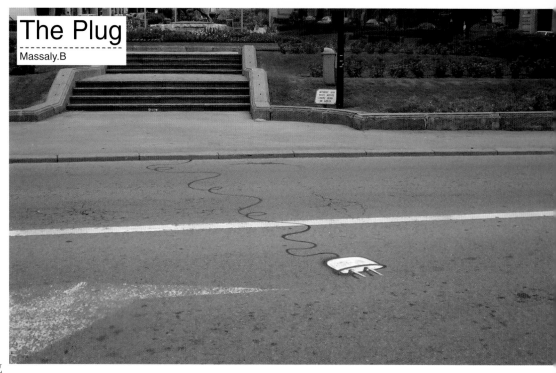

http://www.theplug.be.tf/

Name: PINKYONE AKA PINKY AKA "THE PLUG"

Age: 24 YEARS OLD

Hometown: MESSANCY (EXTREME SOUTH OF BELGIUM)

Cities where to find your art: ARLON - METZ - NANCY - LUXEMBOURG - PARIS - LIEGE

How did you come up with your character? Do you have a special message? THE PURPOSE OF "THE PLUG" IS TO SYMBOLIZE OF BREAK WITH THE SYSTEM, TURN OFF THE MATRIX, PEOPLE ARE SLAVE OF THE SYSTEM AND THE GOUVERNMENT ... WE MUST UNPLUGG THE SYSTEM !

How did you get into street art and when? 3 YEARS AGO, I'VE SEEN A REPORT ON ZEUS'S WORK, SINCE I EAT STREET ART EVERYDAY

Other street artists you admire / respect and why? ZEUS - SPACE - L'ATLAS - ALEXONE - SHEPARD FAIREY THE ORIGINALITY OF CONCEPTS PUT ME ON MY KNEES HEHEHE ...

Other interests: GRAFFITI - PAINTING - DRINK COFFEE - HAVE CHILL WITH MY FRIENDS AND MY CREWS THE '268' AND THE 'JUNGLE TACTICS'.

How does a typical day in your life look like? DO GRAFFITI AND CANVAS SPEND MY AFTERNOONS TO CHILL AND DRINK COFFEES WITH 'TURTLE BOY' AT 'KNOPES COFFEE SHOP'

Inspirations: MECHANICAL BEHAVIOR OF PEOPLE IN SOCIETY

Your favorite music? LOUNGE TRIP HOP ACID JAZZ AND BELGIAN POP ROCK SCENE

Did you ever get in trouble as a street artist and what happened?
'JOKER'

What do you think is the future of street-art? Will it increase/decrease? INCREASE WITHOUT ANY DOUBTS. BUT WE HAVE MORE CHANCES TO HAVE MORE REPRESSIONS. "THEY" KNOW WHO WE ARE.

3 Things you couldn' live without and why: GRAFFITI, MY HOMETOWN 'MESSANCY', MY FRIENDS, MY FAMILLY AND MY GIRLFRIEND MISS CND. ALL ARE A GREAT PART OF MY LIFE, I CAN'T IMAGINE MY LIFE WITHOUT THAT

3 things you don't like: ALL KIND OF ADVERTISING, THE MULTINATIONAL COMPANIES, LIES, SOCIAL INEQUALITY AND COLD COFFEE !!

Any advise? SEIZE THE DAY !!!

SPECIAL THANXX TO ALL PEOPLE WHO SHARE MY LIFE AND GIVE ME SUPPORT (YOU KNOW WHO YOU ARE!) PEACE

PINKYONE
St - 268.

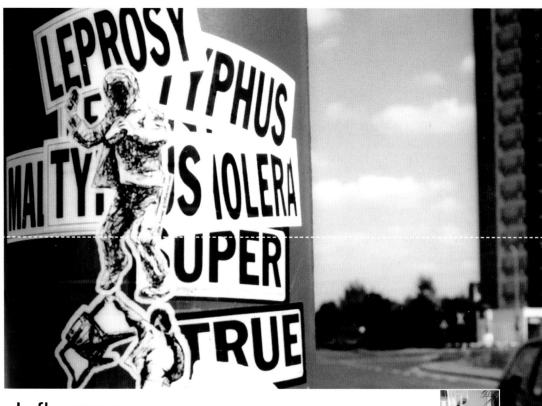

Influenza
Rotterdam.NL

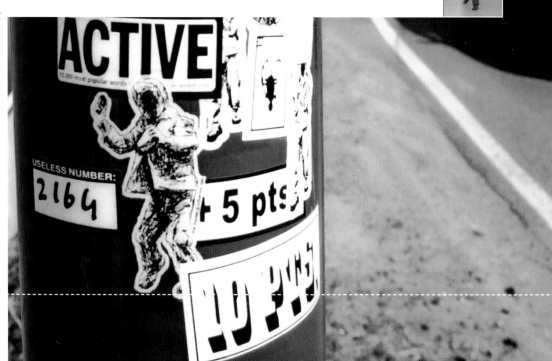

>> Name: INFLUENZA

>> Age: I stopped counting after the year 1968. A failed revolution that year, made all getting more blurry after that. Felled like I was only 15 in the year 1989 though. But I wasn't.

>> Hometown:
Between Paris and Rotterdam, the cities of love and hate.

>> Cities where to find your art:
All around because of the internet. But uptill now I only walked the streets of Europe. Would love to go to Africa though. Start a little streetart-school there.

>> How did you come up with your character? Do you have a special message? or a food chain (what ever that is).
I use more than just one character. Texts as eyecatchers, diseases and little rioteers, small figures on stickers. The fly-figure was a thing indirectly taken from the dutch toilets. Toilet-fabricators put thing in the ceramics of the urinoir so man try to piss it away. After they introduced that fly trick the bathroom floors kept clean in bars and other public places, designers saw a big future for subtle manipulation of mankind. I started to use this fly in an attempt to resist that manipulation by putting my own flies next to the official ones. In a way to give the toilet users a second choice..to piss on my sticker. The more graphical spin off I use as a rude weapon in the streets to censor what I don't like (like cheap sexist ads to promote facepaint or soap for hear etc.) or support what I like by landing the fly next to it. A narrow border, nice to walk. Special warfare message: Sun-tsu said: "Attack the blind where he expects it the least: the eye's. Attack the greedy where it hurts him the most: the wallet."

>> How did you get into street art and when?
Don't remember exactly. My mother delivered me in a cab on way to the hospital. Suppose it started there, or quick after.

>> Other street artists you admire / respect and why?
There are a lot, but one to mention surely is Erosie from the Netherlands. We did and do a lot of different projects together and he's a good inspiration for me. His attitude and styles are amazing and he is a good pusher for the scene he is in. We have the same idea's about the importance of that. Without a social attitude there is no platform, there is no scene, no interesting feedback etc. Other brothers in arms in random order: Space3, Honet, the Betamaxxxers, Fars, Reinaart Vanhoe, Marc Bijl, Pino Boresta, the Toasters, Stak, Fancy, Earl, Zime, de Kemphanen, the complete international AOUW bat

>> Other interests:
I collect stickers, haha!

>> How does a typical day in your life look like?
Rise, produce some traces of existence and fall again, to rise the next day again.

>> Inspirations: All the traces man can make in life to leave their mark. From architecture that can fuck up everyday life to the scratches on its walls, left behind after a carcrash; A book on the pavement with a text about the work and life on Robert Smithson; 1600century graffiti in the Amsterdam palace; beautiful weather in a new city you walk through with a pack of stickers in your pocket; that can gives you the glimps of 'almost utopian'. Also irritation works quite good for coming to good ideas.

>> Your favorite music?
"The art of noise" (..I hate their music though).

>> Did you ever get in trouble as a street artist and what happened?
Sorry, but I hate the label 'streetartist'. I think you are buzzy with art or you ain't. If it uses the street, an artspace or a magazine as a podium doesn't make a big difference. Just a shift in context. The classical artscene always tried to ridiculize the graffiti and postgraffiti scene , perhaps cause that people had the guts to take bigger risks than most classical artists wanted to take. The label 'streetart' is a result of that. Imagine, artists already worked on the streets and in other ways away from the commercial galleries in the 1920s and after. In the 50s till the 70s it was a common thing to go in the streets to do For the rest the regular. Caught in the act. Little bills, some overnights at the station and the usual bla bla. If you don't take any risks you don't go anywhere. secret they even have to push that limits. Stepping over those and playing with it is part of that job. Doing your reports back home is another.

>> What do you think is the future of street-art? Will it increase/decrease?
Pffew, I don't know man. The word-street art has become just a trademark. This commercialization and exploitation will have big effects on the way others look at the scene and the visuals produced. It will be just and nothing more than design, further and further away from the things that should matter. A little logo posted here, a little logo posted there, and two weeks later the T-shirt comes out. On the other hand artists that keep on using illegality as their tools to work with, will feel the pressure of the law increase. With all new pseudo-terrorism laws being designed and possibilities for cops, we all should get used to more camouflaging in the future. Right now the situation in Paris is already starting to get fucked up with undercover cops filming people underground-like events. Imaging what they are allowed to do10 years from now. Hope that people keep on resisting this stuff though and keep on

>> 5 Things you couldn't live without and why: finding ways to deal with it. I won't stop anyway.
Just two: anger and love. It's amazing to see the power of these works in two simple sentences: "I hate you!", "I love you!". Who needs more than those two tricks for an energetic life. The rest is just decoration and camouflage.

>> Things you don't like:
It is hard to see people that used to be straight and working to be pure and then fall for the money, sell their ass and that of their friends. I am really fed up with pseudo-graffiti commercial design exploiting other peoples work and risks taken. "Disobey your thirst!"

>> Any advise?
Get a normal job, slow career, pay taxes, vote every four years something in the middle, don't trust your neighbor but trust the police and die with regrets. Good night.

Invader
Paris.FRA

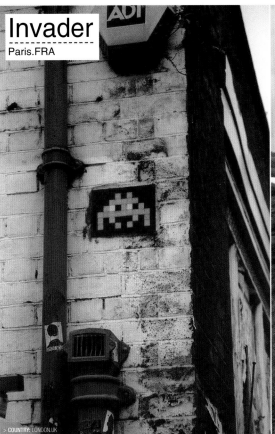

> COUNTRY: LONDON.UK

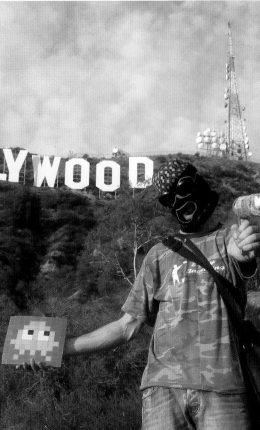

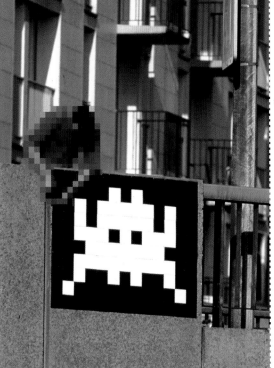

>> Name: **INVADER, SPACE**

>> Age: **NONE**

>> Hometown: **EARTH**

>> Cities where to find your art: **25 CITIES AROUND THE WORLD / 05 2003**

>> How did you come up with your character? Do you have a special message?

I LOVE VIRUS

>> How did you get into street art and when?

THE DAY I CEMENTED MY FIRST MOSAIC IN PARIS IN 1996

>> Other street artists you admire / respect and why?

SHEPARD FAIREY, REVS, ZEVS, GORDON MATTA CLARK, KAMI JEROEN

>> Other interests:

YES

>> How does a typical day in your life look like?

EVERY DAY IS DIFFERENT FROM THE DAY BEFORE.

>> Inspirations: **YES, SOMETIMES.**

>> Your favorite music? **I LIKE EVERY KIND OF MUSICS.**

>> Did you ever get in trouble as a street artist and what happened?

I'M OK !

>> What do you think is the future of street-art? Will it increase / decrease?

WAIT AND SEE.

>> 5 Things you couldn't live without and why:
**INVADE
USE MY COMPUTER
JULIE MY GIRLFRIEND
COCAIN**

>> Things you don't like:
**RIDING MY SCOOTER WHEN IT RAINS
BIG BRANDS
ANTI VIRUS SOFTWARES**

>> Any advise?

GAME NOT OVER.

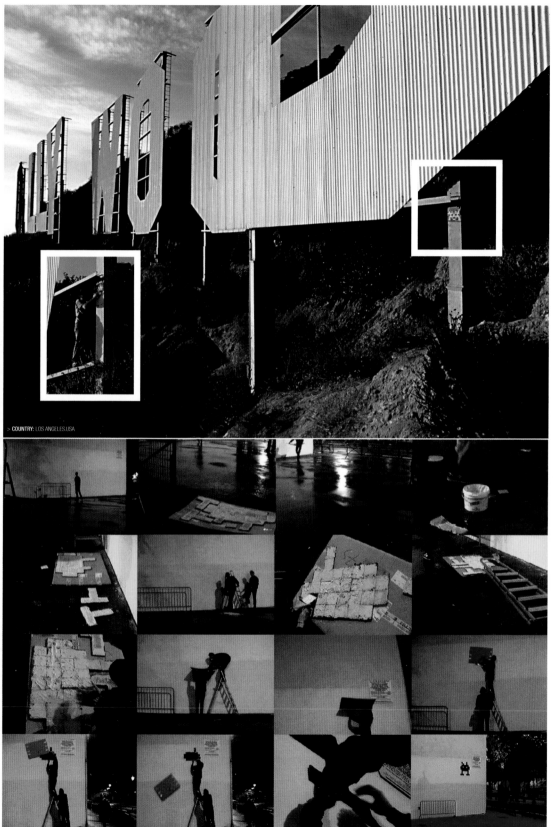

> **COUNTRY:** LOS ANGELES.USA

The Flower Guy
New York.USA

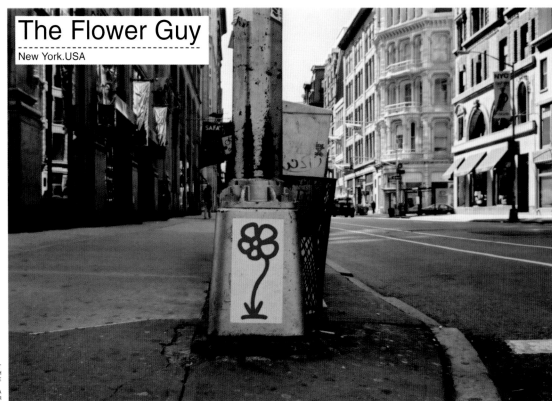

http://www.mdefeo.com/

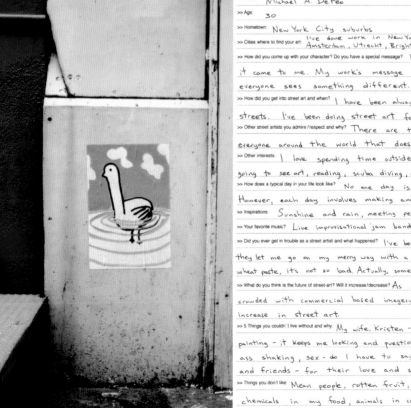

>> Name: Michael A. DeFeo

>> Age: 30

>> Hometown: New York City suburbs

>> Cities where to find your art: I've done work in New York, San Francisco, Seattle, Boston, Amsterdam, Utrecht, Brighton, Vancouver and soon your town!

>> How did you come up with your character? Do you have a special message? I wasn't looking for it and it came to me. My work's message is up to each viewer, everyone sees something different.

>> How did you get into street art and when? I have been always drawn to the energy of the streets. I've been doing street art for the past ten years, since 1993.

>> Other street artists you admire / respect and why? There are too many to mention here... everyone around the world that does it from their hearts.

>> Other interests: I love spending time outside, creating, playing, dancing, going to see art, reading, scuba diving, cooking, problem solving, etc...

>> How does a typical day in your life look like? No one day is typical, that is what I love! However, each day involves making and sharing to some degree.

>> Inspirations: Sunshine and rain, meeting people, travelling, children, everything...

>> Your favorite music? Live improvisational jam bands

>> Did you ever get in trouble as a street artist and what happened? I've been hassled many times... usually they let me go on my merry way with a fine or a warning. Because I wheat paste, it's not so bad. Actually, some cops have complemented my work.

>> What do you think is the future of street-art? Will it increase/decrease? As our environment continues to get crowded with commercial based imagery, there will surely be an increase in street art.

>> 5 Things you couldn' t live without and why: My wife, Kristen - she's my entire world, painting - it keeps me looking and questioning, music - it keeps my ass shaking, sex - do I have to say why?, all of my family and friends - for their love and support

>> Things you don't like: Mean people, rotten fruit, stones in my shoes, chemicals in my food, animals in cages

>> Any advise? Don't waste any time! Create and celebrate!

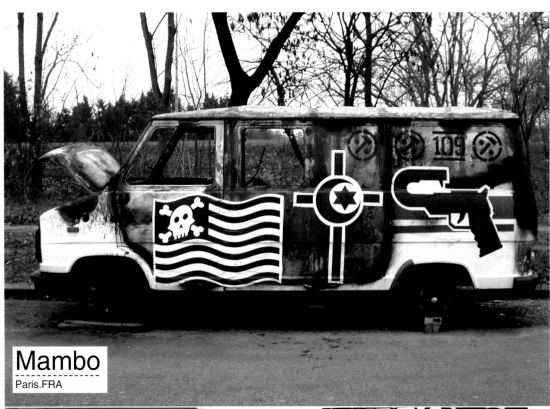

Mambo
Paris.FRA

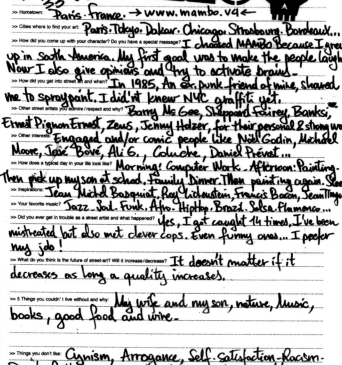

MAMBO

>> Name: Flavien Demariguy
>> Age: 33
>> Hometown: Paris. France. → www.mambo.vg ←
>> Cities where to find your art: Paris. Tokyo. Dakar. Chicago. Strasbourg. Bordeaux...
>> How did you come up with your character? Do you have a special message? I choosed MAMBO Because I grew up in south America. My first goal was to make the people laugh. Now I also give opinions and try to activate brains.
>> How did you get into street art and when? In 1985, An ex punk friend of mine, showed me to spraypaint. I did'nt knew NYC graffiti yet.
>> Other street artists you admire / respect and why? Barry Mc Gee, Sheppard Fairey, Banksi, Ernest Pignon Ernest, Zeus, Jenny Holzer, for their personal & strong work.
>> Other interests: Engaged and/or comic people like Noël Godin, Michael Moore, José Bové, Ali G., Coluche, Daniel Prévost...
>> How does a typical day in your life look like? Morning: Computer Work. Afternoon: Painting. Then pick up my son at school. Family Dinner. Then painting again. Sleep.
>> Inspirations: Jean Michel Basquiat, Roy Lichtenstein, Francis Bacon, SeanTinguy.
>> Your favorite music? Jazz. Soul. Funk. Afro. HipHop. Brazil. Salsa. Flamenco...
>> Did you ever get in trouble as a street artist and what happened? Yes, I got caught 14 times, I've been mistreated but also met clever cops. Even funny ones... I prefer my job !
>> What do you think is the future of street-art? Will it increase/decrease? It doesn't matter if it decreases as long a quality increases.
>> 5 Things you couldn't live without and why: My wife and my son, nature, music, books, good food and wine.
>> Things you don't like: Cynism, Arrogance, Self-satisfaction. Racism. People falling in the stupid traps of our world.
>> Any advise ? If you haven't study, go traveling. Stay away from fashion, develope your personality.

ISSUE
JBLIC
UCATIO

Regular Product
Sidney.AU

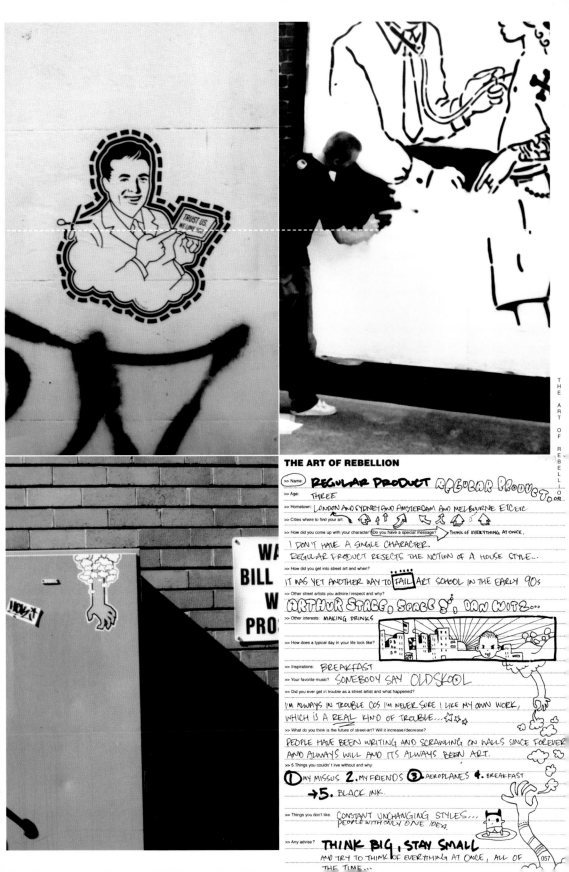

THE ART OF REBELLION

>> Name: **REGULAR PRODUCT** REGULAR PRODUCT OR

>> Age: THREE

>> Hometown: LONDON AND SYDNEY AND AMSTERDAM AND MELBOURNE ETC ETC

>> Cities where to find your art:

>> How did you come up with your character? Do you have a special message? → THINK OF EVERYTHING AT ONCE.

I DON'T HAVE A SINGLE CHARACTER.
REGULAR PRODUCT REJECTS THE NOTION OF A HOUSE STYLE...

>> How did you get into street art and when?

IT WAS YET ANOTHER WAY TO FAIL ART SCHOOL IN THE EARLY 90s

>> Other street artists you admire / respect and why?

ARTHUR STACE, SPACE 3°, DAN WITZ...

>> Other interests: MAKING DRINKS

>> How does a typical day in your life look like?

>> Inspirations: BREAKFAST

>> Your favorite music? SOMEBODY SAY OLDSKOOL

>> Did you ever get in trouble as a street artist and what happened?

I'M ALWAYS IN TROUBLE COS I'M NEVER SURE I LIKE MY OWN WORK,
WHICH IS A REAL KIND OF TROUBLE...

>> What do you think is the future of street-art? Will it increase/decrease?

PEOPLE HAVE BEEN WRITING AND SCRAWLING ON WALLS SINCE FOREVER
AND ALWAYS WILL AND ITS ALWAYS BEEN ART.

>> 5 Things you couldn't live without and why:

① MY MISSUS 2. MY FRIENDS ③ AEROPLANES 4. BREAKFAST
→ 5. BLACK INK.

>> Things you don't like: CONSTANT UNCHANGING STYLES....
PEOPLE WITH ONLY ONE IDEA.

>> Any advise? **THINK BIG, STAY SMALL**
AND TRY TO THINK OF EVERYTHING AT ONCE, ALL OF
THE TIME...

057

Buffmonster
Los Angeles.USA

>> Name: BUFF MONSTER

>> Age: 24

>> Hometown: HONOLULU

>> Cities where to find your art: YOU CAN DEFINITELY FIND IT IN LA.

>> How did you come up with your character? Do you have a special message?

WHEN I WAS 5 YEARS OLD, MY DAD GAVE ME A STICKER FROM TOKYO. I THINK THAT IT GOT LODGED IN MY SUBCONSCIOUS.

>> How did you get into street art and when? I GOT INTO STREET ART WHEN I GOT TIRED OF GRAFFITI. THAT WAS ABOUT 5 YEARS AGO.

>> Other street artists you admire / respect and why? THERE ARE SO MANY GREAT STREET ARTISTS IN EUROPE. THEY'RE MUCH MORE CREATIVE AND FUN-LOVING OVER THERE.

>> Other interests: BESIDES ART AND GRAPHIC DESIGN AND ALL THE PREDICTABLE THINGS, PORN CAN BE RATHER FASCINATING. SELF-IMPROVEMENT IS REALLY IMPORTANT.

>> How does a typical day in your life look like? I SHOWER, THEN SHOW UP AT WORK ABOUT 15 MINUTES LATE. I SIT IN A TAN CUBICLE ALL DAY, THEN WORK AT HOME UNTIL I GO TO BED.

>> Inspirations: ICE CREAM, PORN, GRAFFITI, LOS ANGELES, ROCK N' ROLL.

>> Your favorite music? HEAVY METAL, AND NOT SO HEAVY METAL

>> Did you ever get in trouble as a street artist and what happened?

I GOT IN TROUBLE AS A GRAFFITI ARTIST...

>> What do you think is the future of street-art? Will it increase/decrease? IT CERTAINLY WON'T DIE OFF. IT'S JUST GOING TO GET BIGGER, BETTER, AND MORE INTERESTING. I LOOK FORWARD TO TALKING ABOUT "THE OLD DAYS."

>> 5 Things you couldn't live without and why: MY TOOTHBRUSH, BECAUSE DENTAL WORK CAN BE "UNPLEASANT." MY PHONE, BECAUSE I NEED TO TALK TO FRIENDS AND FAMILY. LIVING IN LA, HAVING A CAR IS VERY IMPORTANT. I DON'T THINK I COULD LIVE WITHOUT A REFRIGERATOR AND 1 OTHER THING.

>> Things you don't like: BROCCOLI, BIG EGOS, FLAKY PEOPLE, BEING TOLD HOW TO LIVE MY LIFE, POLITICS

>> Any advise? DON'T TAKE GRAFFITI OR STREET ART TOO SERIOUSLY.

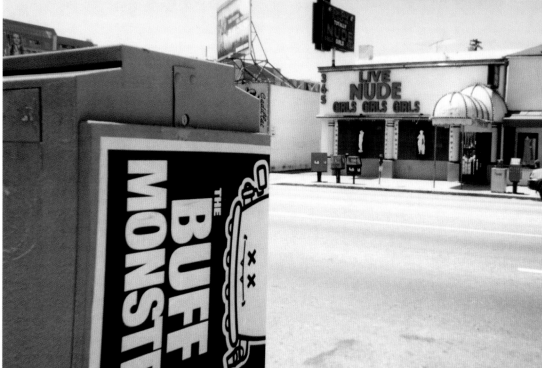

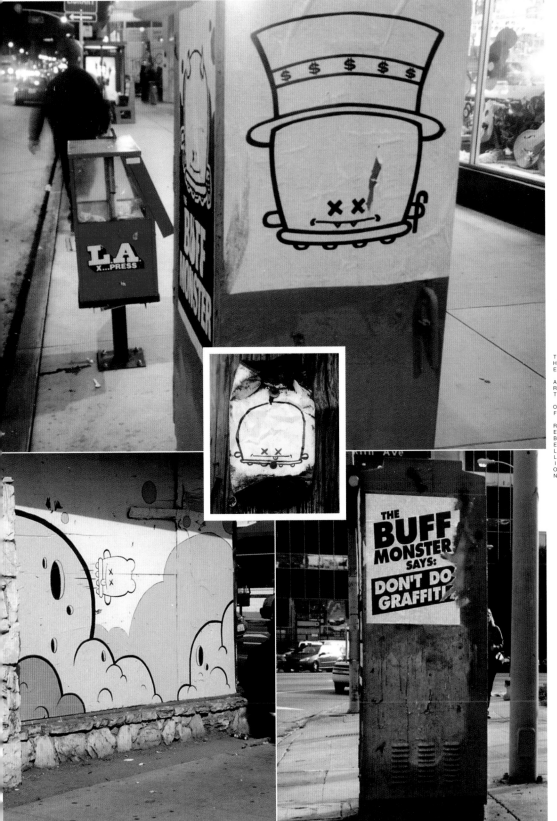

Stak
Paris.FRA

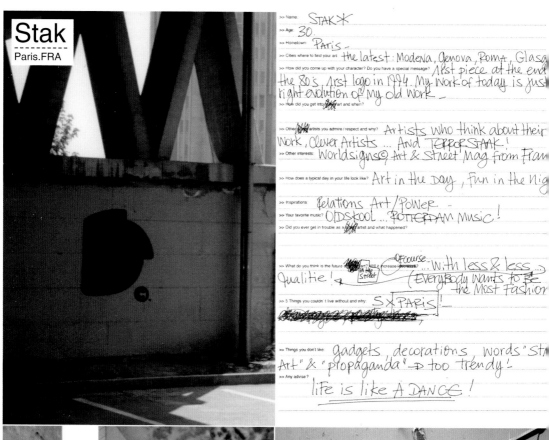

>> Name: STAK ✱
>> Age: 30.
>> Hometown: Paris.
>> Cities where to find your art: the latest: Modena, Genova, Roma, Glasg[ow]
>> How did you come up with your character? Do you have a special message? 1rst piece at the end [of] the 80's, 1rst logo in 1994. My work of today is just [the] right evolution of my old work.
>> How did you get into [your] art and when?

>> Other artists you admire / respect and why? Artists who think about their work, clever artists ... And TERROR STAAK!
>> Other interests: Worldsigns© Art & Street Mag from Fran[ce]
>> How does a typical day in your life look like? Art in the Day, Fun in the Nig[ht]
>> Inspirations: Relations Art / Power.
>> Your favorite music? OLDSKOOL ... ROTTERDAM music!
>> Did you ever get in trouble as [an] artist and what happened?

>> What do you think is the future [of] art? Will it increase / decrease? Ofcourse ... with less & less Qualitie! in the street (everybody wants to be the most fashion[able]
>> 5 Things you couldn't live without and why: 5 ✗ PARIS!

>> Things you don't like: gadgets, decorations, words "Str[eet] Art" & "propaganda" → too trendy!
>> Any advise? life is like A DANCE!

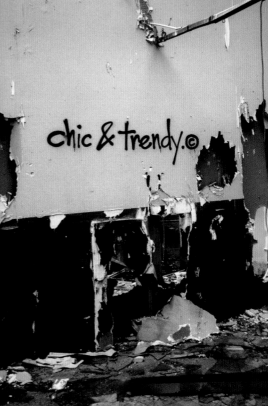

chic & trendy.©

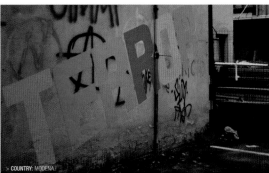

> COUNTRY: MODENA I

> COUNTRY: MODENA I

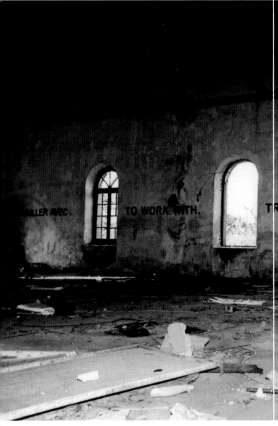

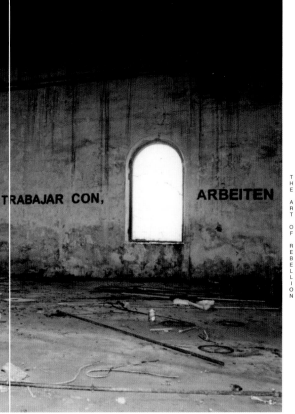

ALLER AVEC, TO WORK WITH, TRABAJAR CON, ARBEITEN

THE ART OF REBELLION

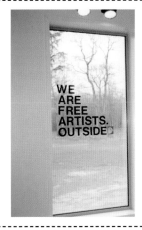

WE
ARE
FREE
ARTISTS.
OUTSIDE

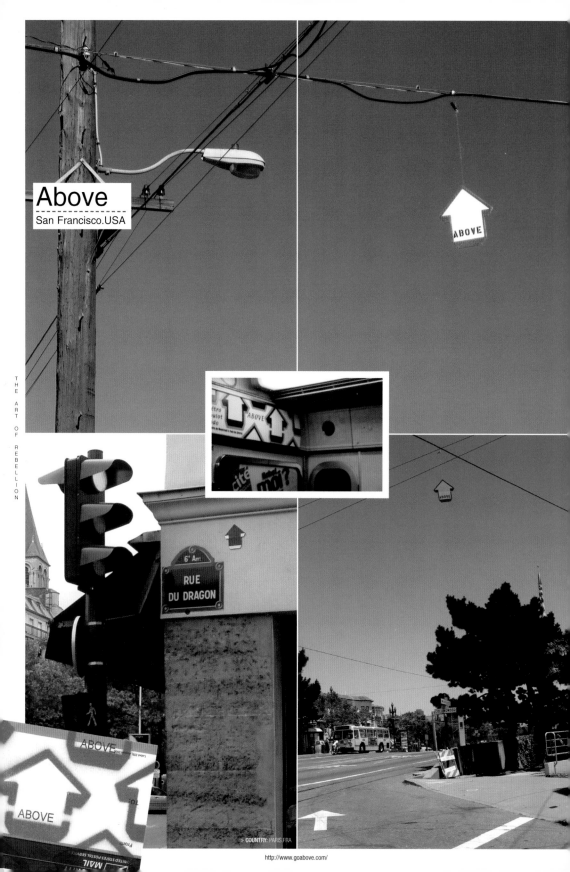

Above
San Francisco.USA

THE ART OF REBELLION

ABOVE

RUE DU DRAGON

6ᵉ Arr

> COUNTRY: PARIS.FRA

http://www.goabove.com/

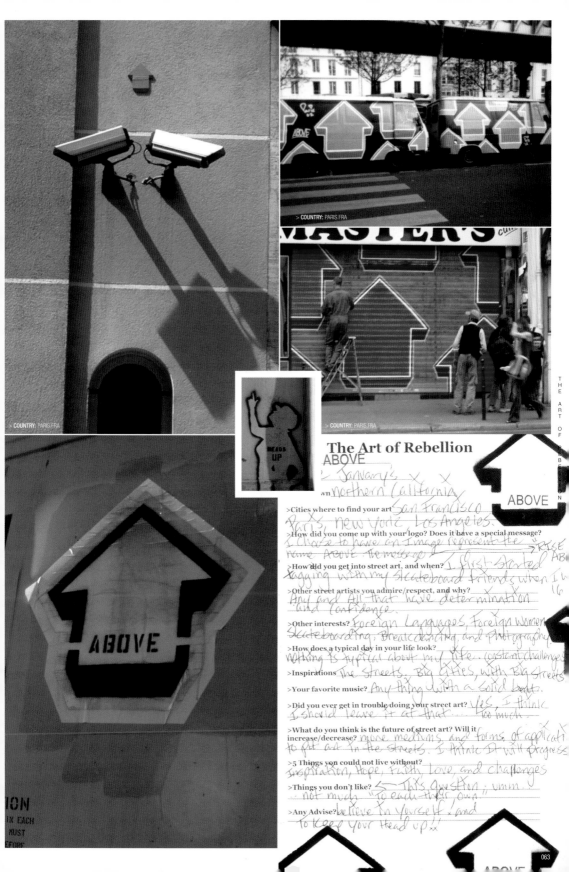

MASTER'S

HEADS UP

The Art of Rebellion

ABOVE

January's

Northern California

>Cities where to find your art San Francisco, Paris, New York, Los Angeles.

>How did you come up with your logo? Does it have a special message? I chose to have an image represent the name ABOVE. The message "RISE ABOVE"

>How did you get into street art, and when? I first started tagging with my skateboard friends when I was 16

>Other street artists you admire/respect, and why? Any and All that have determination and confidence.

>Other interests? Foreign Languages, Foreign Women Skateboarding, Breakdancing, and Photography

>How does a typical day in your life look? Nothing is typical about my life. (constant challenges)

>Inspirations The streets, Big cities, with Big streets

>Your favorite music? Any thing with a solid beat.

>Did you ever get in trouble doing your street art? Yes, I think I should leave it at that... too much.

>What do you think is the future of street art? Will it increase/decrease? More mediums and forms of application to put art in the streets. I think it will progress.

>5 Things you could not live without: Inspiration, Hope, Faith, Love, and Challenges

>Things you don't like? — This question; umm. not much "To each their own"

>Any Advise? believe in yourself! and to keep your head up!!

ABOVE

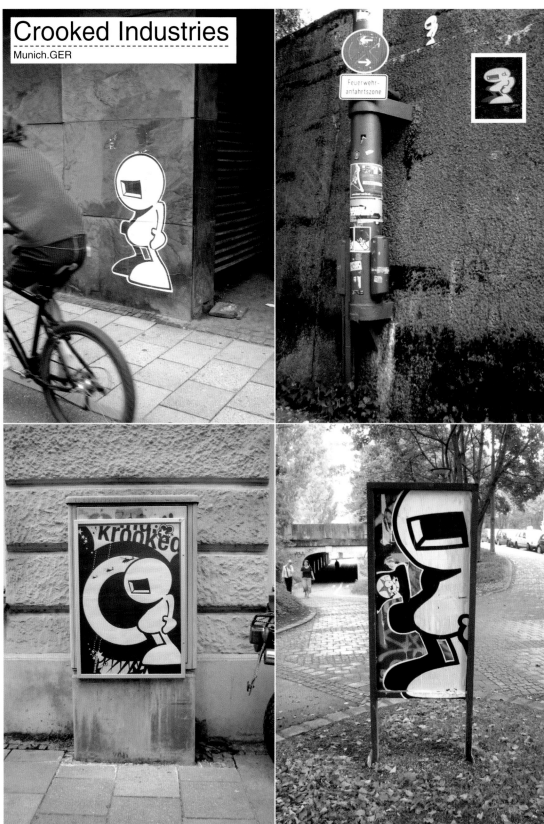

Crooked Industries
Munich.GER

THE ART OF REBELLION

>> Name: CROOKED INDUSTRIES

>> Age: 18 SINCE THE EARLY 90S

>> Hometown: MUNICH

>> Cities where to find your art: MOSTLY MUNICH, SOME STUFF ALSO IN BERLIN, LONDON, BERGAMO, DUSSELDORF, VIENNA.-HOPEFULLY SOON IN YOUR AREA.

>> How did you come up with your character? Do you have a special message?
I WANTED TO CREATE A WEIRD "CROOKED "CHARACTER THAT SHOULD MAKE PEOPLE SMILE AND AMUSE THEM. SO, MR.KROOK WAS BORN BUT AFTER THE WAR IN IRAQ STARTED MR.KROOK THOUGHT IT MIGHT BE BETTER TO DISGUISE & GET A SUIT OF ARMOR. NOW HE DRESSES UP IN HIS NICE NEW SUIT WHICH IS MORE COMFORTABLE.

>> How did you get into street art and when?
I'VE BEEN WRITING GRAFFITI SINCE 89 -I WAS LOOKING FOR SOMETHING NEW, FRESH. I ALWAYS THOUGHT I'D. BE COOL TO CREATE SOMETHING THAT REACHES A GREATER AUDIENCE, WITH THE AIM TO ENTERTAIN PEOPLE, EVENTUALLY MAKE THEM LAUGH.THEN I READ AN ARTICLE ABOUT STREETART. THE REST IS HISTORY.

>> Other street artists you admire / respect and why?
RATHER ANYONE WHO IS ACTIVE AND KEEPS ON DOING NEW STUFF. I REALLY PAY RESPECT TO INVADER, ZEVS, THE LONDON POLICE, BANKSY, FAIREY, BECAUSE THEY WERE THE FIRST ONES I SAW DOING URBAN ART.

>> Other interests
MY GIRL, DESIGN & ART, SOME SPORTS (CATCHING BRUISES AND GRACES ON RAMPS), MUSIC

>> How does a typical day in your life look like?
AT THE MOMENT QUITE HECTIC- LITTLE SLEEP- A LOT OF WORK- IN THE MEANTIME THINKING ABOUT DESIGN AND ART OR HOW NICE IT WOULD BE TO SHARE MORE TIME WITH MY GIRL & FRIENDS....

>> Inspirations: GRAPHIC DESIGN, ILLUSTRATION, ART, LIFE SITUATIONS.

>> Your favorite music? ANYTHING THAT SATISFIES MY APPETITE FOR GOOD MUSIC- MOSTLY ELEC-
TRONIC MUSIC. ALSO EARLY 90'S HIP HOP & PUNK, HARDCORE, BRASIL;...........

>> Did you ever get in trouble as a street artist and what happened?
ON ONE OF MY FIRST TIMES OUT IN THE STREETS THE POLICE STOPPED ME AND ASKED ME WHAT I WAS DOING- I WAS JUST PUTTING UP SOME POSTERS. I TOLD THEM A STORY ABOUT A PR-GUERILLA MARKETING THING OF AN ADVERTISING AGENCY AND IT WORKED.
FROM THEN ON IT WENT OK - FINGERS CROSSED

>> What do you think is the future of street-art? Will it increase/decrease?
IT WILL INCREASE- MORE PEOPLE WILL START - HOPEFULLY "NORMAL" PEOPLE ARE GOING SHARE OUR ENTHUSIASM FOR ART IN THE STREETS AND LIKE IT. ON THE OTHER HAND THE INDUSTRY WILL ALSO RECOGNISE IT AND WILL TRY TO TAKE THEIR BENEFIT OUT OF IT. AFTER A WHILE THEY WILL DROP IT, LIKE USUALLY. BUT I THINK THIS WON'T AFFECT THE ONES WHO ARE INTO IT WITH THEIR HEART.

>> 5 Things you couldn't live without and why
1. FAMILY & (GIRL)FRIEND(S),
2. MY EYES & HANDS,
3. A PIECE OF PAPER AND A PEN.
4. MUSIC
5. NICE WEATHER

>> Things you don't like: (LIKE COMPUTERS)
I'M NOT VERY PATIENT- I HATE IT WHEN SOMETHING DOESN'T WORK
- HAVING A STRESSFUL LIFE - IGNORANT PEOPLE

>> Any advise ?
KEEP ON KEEPING ON!

Maciek
Bordeaux.FRA

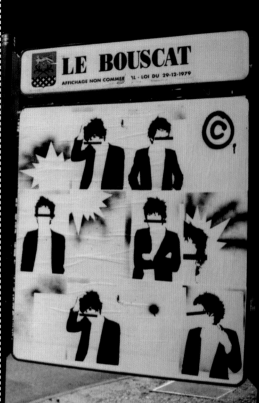

THE ART OF REBELLION

>> Name: Maciek
>> Age: Twenty
>> Hometown: Bordeaux, FRANCE
>> Cities where to find your art:

>> How did you come up with your character? Do you have a special message?

>> How did you get into street art and when? I started graffiti when i was about 13 years old with friends of my school.
>> Other street artists you admire/respect and why? I would say Basquiat. He influenced a lot of nowdays artists.
>> Other interests: Music, contemporary art, painting...

>> How does a typical day in your life look like? like every other day.

>> Inspirations: *MUSIC, people...
>> Your favorite music? Garage Rock

>> Did you ever get in trouble as a street artist and what happened? I get caught by the cops a couple of times, but it never ended badly.

>> What do you think is the future of street-art? Will it increase/decrease?

>> Things you couldn't live without and why My two hands

>> Things you don't like: Boring things

>> Any advise?

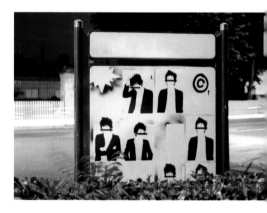

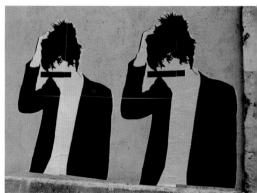

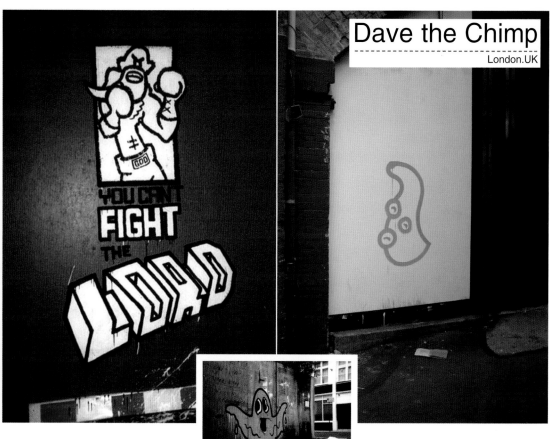

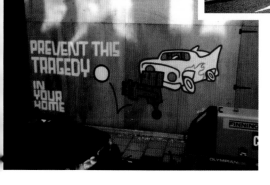

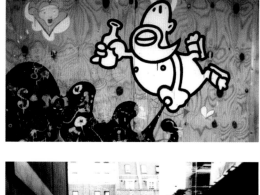

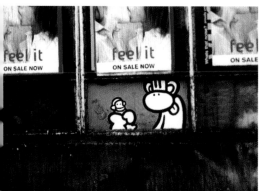

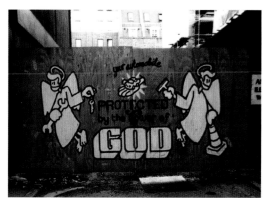

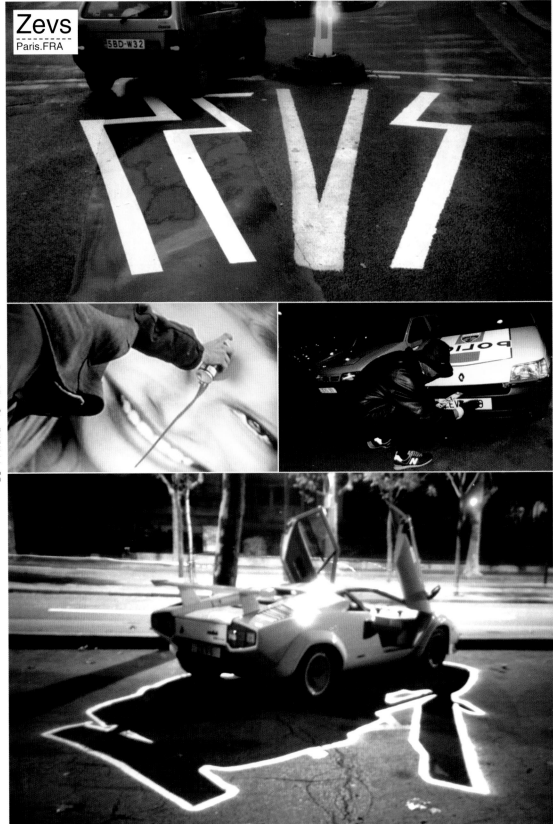

THE ART OF REBELLION

"ARTRESTING" BY ZEVS:
IN AN HYPER SECURED WORLD, NOT TO SAY OVER SECURED,
THE "ARTRESTINGS" BY ZEVS IS AN ARTISTIC AND HUMOROUS
ANSWER TO THAT SLOW LOOSE OF LIBERTY. POEPLE COME
BY APPOINTMENT TO THE COMITÉ DE SALUT ARTISTIQUE IN
PARIS AND GET ARTRESTED FOR ANY POETIC OR PERSONAL
REASON. AND IN FACT ANY REASON IS GOOD ENOUGH TODAY
TO BE ARRESTED, SORRY, "ARTRESTED"?
ALAIN BRODERS FOR THE C.S.A.

THE ART OF REBELLION

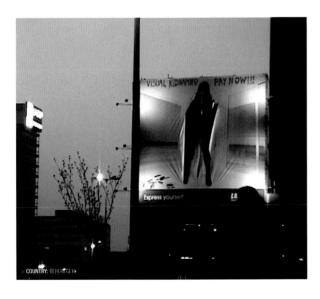

> COUNTRY: BERLIN GER

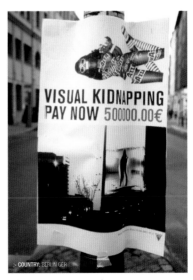

> COUNTRY: BERLIN GER

Supa_kitch
Montpellier.FRA

no webaddress

THE ART OF REBELLION

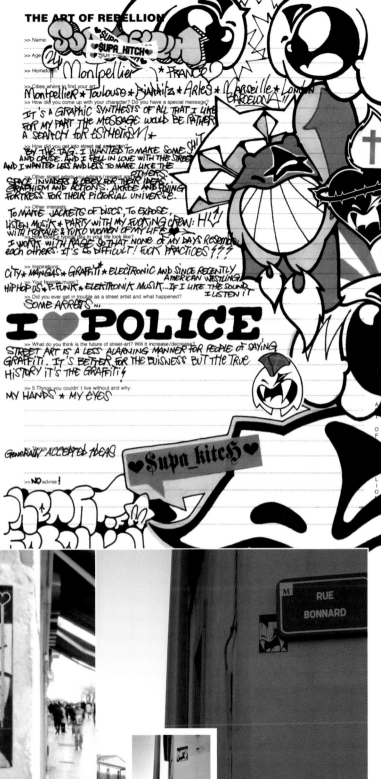

>> Name: **$UPA KiTCH**

>> Age: **24**

>> Hometown: **Montpellier * FRANCE**

>> Cities where to find your art:
Montpellier * Toulouse * Biarritz * Arles * Marseille * London BARCELONA''

>> How did you come up with your character? Do you have a special message?
IT'S A GRAPHIC SYNTHESIS OF ALL THAT I LIKE FOR MY PART THE MESSAGE WOULD BE RATHER A SEARCH FOR ESTHETISM *

>> How did you get into street art and when?
BY THE TAG. I WANTED TO MAKE SOME SHIT AND CAUSE. AND I FELL IN LOVE WITH THE STREET AND I WANTED LESS AND LESS TO MAKE LIKE THE OTHERS.

>> Other street artists you admire/respect and why:
SPACE INVADERS & OBEY FOR THEIR IDEAS, GRAPHISM AND ACTIONS. AKROE AND BYING FORTRESS FOR THEIR PICTORIAL UNIVERSE.

>> Other interests:
TO MAKE JACKETS OF DISCS, TO EXPOSE, LISTEN MUSIK * PARTY WITH MY FUCKING CREW: HK'' WITH KORAYE & YUKO WOMEN OF MY LIFE

>> How does a typical day in your life look like?
I WORK WITH RAGE SO THAT NONE OF MY DAYS RESEMBLE each others. IT'S SO DIFFICULT! FUCK PRACTICES $$$

>> Inspirations:
CITY * MANGAS * GRAFFITI * ELECTRONIC AND SINCE RECENTLY AMERICAN WRESTLING

>> Your favorite music?
HIPHOP DJS * P-FUNK * ELEKTRONIK MUSIK... IF I LIKE THE SOUND I LISTEN IT

>> Did you ever get in trouble as a street artist and what happened?
SOME ARRETS''

I ♥ POLICE

>> What do you think is the future of street-art? Will it increase/decrease?
STREET ART IS A LESS ALARMING MANNER FOR PEOPLE OF SAYING GRAFFITI. IT'S BETTER FOR THE BUISNESS BUT THE TRUE HISTORY IT'S THE GRAFFITI$

>> 5 Things you couldn't live without and why:
MY HANDS * MY EYES

Generally ACCEPTED IDEAS ♥ **$upa_kitch** ♥

>> **NO** advise **!**

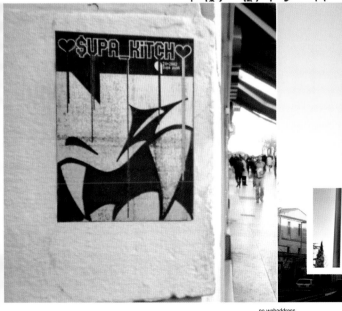

RUE BONNARD

Shepard Fairey
Los Angeles.USA

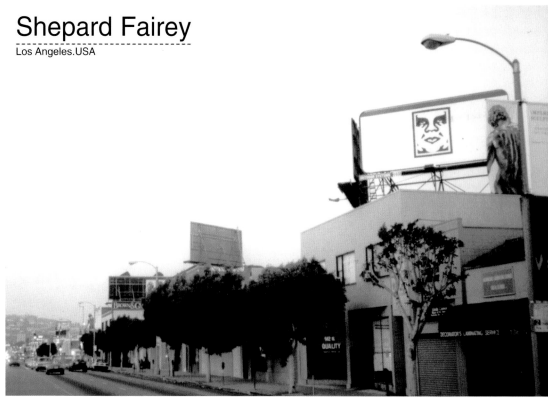

COUNTRY: LONDON.UK

COUNTRY: LONDON.UK

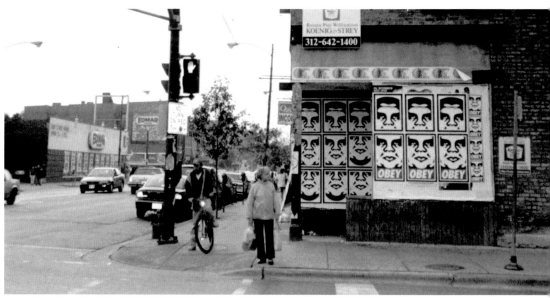

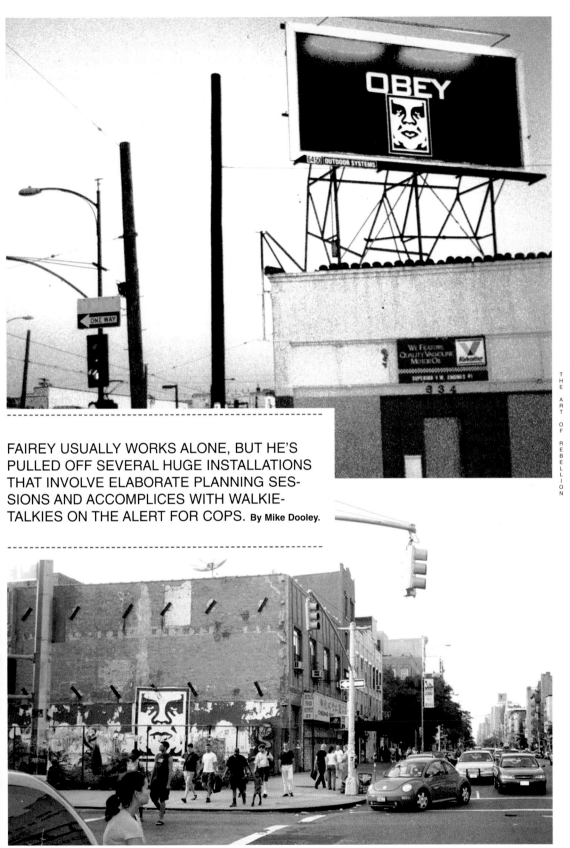

FAIREY USUALLY WORKS ALONE, BUT HE'S PULLED OFF SEVERAL HUGE INSTALLATIONS THAT INVOLVE ELABORATE PLANNING SESSIONS AND ACCOMPLICES WITH WALKIE-TALKIES ON THE ALERT FOR COPS. **By Mike Dooley.**

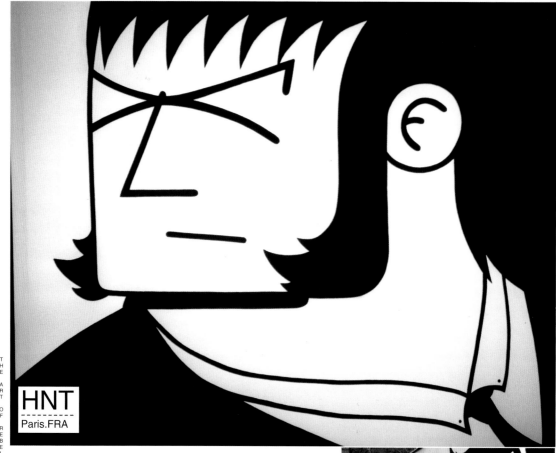

HNT

Paris.FRA

Street-art doesn't exist,
Hip-hop culture doesn't exist,
street-wear doesn't exist,
New-york USA doesn't exist,
Nike sponsoring doesn't exist,
a logo as a name doesn't exist,
Be honest as a graffiti-writter,
and clever as an artist.
Graffiti is not a merchandise!

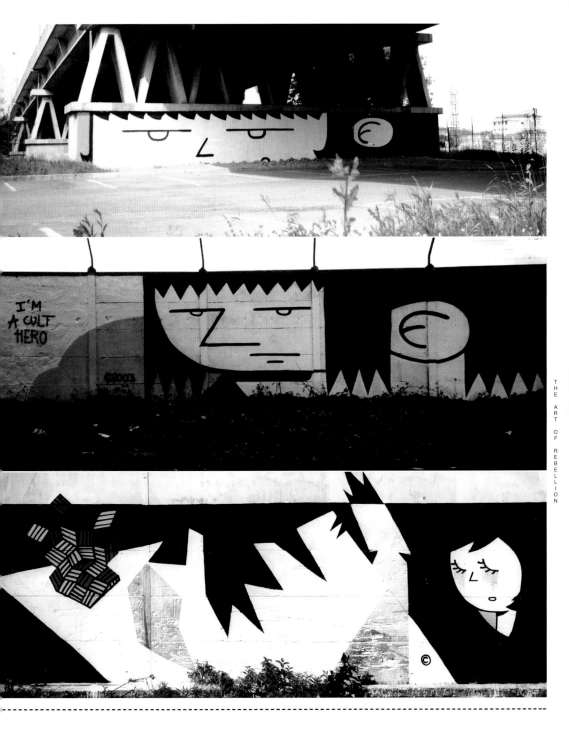

Stirb
Hamburg.GER

>> Name: Stirb...
>> Age: 24 years
>> Hometown: Hamburg
>> Cities where to find your art: everywhere I've been... U.K., Kroatia, Austria, Slovenia, mostly getti-money...
>> How did you come up with your character? Do you have a special message? mostly try to show my anger, it's is always a mixture of very personal issues + political stuff that affects us all. like the gentrification in the cities, or just the architecture concepts... I use to choose something via slogans and create a concept around that. like the URBAN INSECT! BURIED IN CONCRETE AMOK AS ANTWOP STIRB! DO YOU SPEAK PARASITE?
>> How did you get into street art and when? I used to be a sprayer when I was younger, but got bored + frustrated quite fast... when I moved to Hamburg I started writing STIRB! every ... concept
>> Other street artists you admire / respect and why? no where, just becose I hated (still do) most everybody who has something to say, who is pissed of the statusquo. I like the dark side of streetart. the scum crawling ground dropping... sorry.
>> Other interests: my musik project and other ways of working with my thoughts, emotions, fears... like making films... communication in different ways. I think
>> How does a typical day in your life look like? there are just a few things that keep on repeating, like EAT, SLEEP, SHIT, PISS, WANK OFF..... nothing special.
>> Inspirations: ANGER, fight back the I could... getting famous not popular...
>> Your favorite music? Noize not Muzak...
>> Did you ever get in trouble as a street artist and what happened? some time ago I was arrested for spraypainting a train, that will be quite some stress for me I think... mostly people are just pissed and yelling at me, no big deal..
>> What do you think is the future of street-art? Will it increase/decrease? like every subculture, it will be swallowed by the mainstream and will be left as a hollow shell (lifestyle, trend...) in most of the cases.. I think there will be a seperation between the "good + bad" ones
>> 5 Things you won't miss and why: a acceptable place to live, friends, music, sex and food... [why not?]

>> Things you don't like: Hippies, Partys, Cars, most People, no Food, Ignorance, Smokers, cops + other "authorities", nations.... it goes on and on..
>> Any advise?

Bild
Berlin.GER

be an image!

>> Name: Bild.
>> Age: 21 - 27
>> Hometown: BERLIN
>> Cities where to find images: EVERYWHERE!
>> How did you come up with your character? Do you have a special message? I have no clear message. I just wanna give comments on/in urban landscapes first of all I speak out of an individual point of VIEW which is joining more or less an anonymous status in society + play with it!
>> How did you get into street art and when? started with graffiti seven years ago, since three years "street-art"... open END
>> Other street artists you admire / respect and why? everyone who stayed authentic not "REAL"! not many but to much for this culture
>> Other interests: making "music", lazyness, urban explorations....
>> How does a typical day in your life look like? no typical days
>> Inspirations: BOREDOM...?!
>> Your favorite music? no favorite music
>> Did you ever get in trouble as a street artist and what happened? not really... many discussions + spectators
>> What do you think is the future of street-art? Will it increase/decrease? I don't know. Hopefully it will decrease in quality and quantity.
>> 5 Things you couldn't live without and why: bed, humour, sucre, urban landscapes....
◇ Things you don't like: reagge, new-economy punks....etc.
◇ Any advise? NO ADVISE!

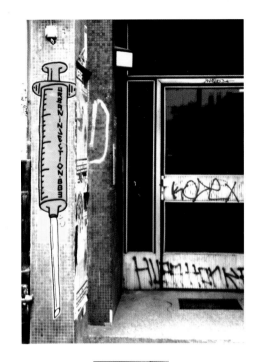

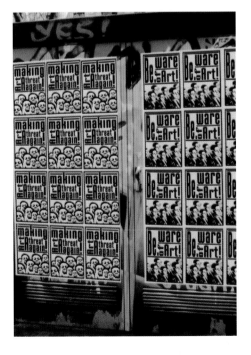

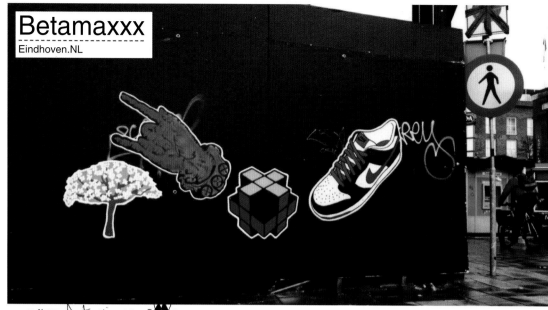

>> Name: BetaMaxxx

>> Age: 1972 STAY OFF THE GRASS

>> Hometown: EINDHOVEN WHUT

>> Cities where to find your art: EHV A'DAM NYC FOAM EVERYWHERE CAPETOWN ISTANBUL A PARIS GENT LONDEN JOHANNESBURG

>> How did you come up with your character? Do you have VE stole it at the library A special AND ADDED THE HEAD OF MISS MESSAGE NANCY REAGAN WICH WE BORROWED OF THE WHITE House WEBSITE + WE took POKEBALL FROM ONE OF THOSE CANDY PACKAGES

>> How did you get into street art and when? WITH FRIENDS GRAFFITI 1985 TO POSTERS N STICKERS TO STENCILS 2 BETAMAX

DOMOKUN

>> Other street artists you admire / respect and why? MIX EVERYBODY FROM OUR HOMETOWN. MFDOOM YOUTROUTH NEWSAVEZ TASTERS. RESPECT IS 1 MASE II automatic/upadare WUDALI STAG/ISS skke jeont & we admire everyone's TALKRIS.com

>> Other interests: AMATEUR PORN BUNKER SHELTERS. PLATFORMS FORMA73 BIOTOPE TALKRIS SHOPLIFTING FREE STUFF

>> How does a typical day in your life look like? NOTHING SPECIAL EAT SLEEP WORK THE USUAL STUFF

>> Inspirations: WE USE EVERYTHING (TRY TO)

>> Your favorite music? SLAYER WEGN MFDOOM TWOLIFE OR THE SCORPIONS HET MARTYN + JOOST TRIO

>> Did you ever get in trouble as a street artist and what DID HAPPEN NOT REALLY, NOTHING JUMPS TO MIND EXEPT ONE OF US GOT Spaanwend verhaal QUARANTINED FOR 10 DAYS AFTER HOLIDAY IN SINGAPORE BECAUSE THE WHOLE SARS SITUATION

>> What do you think is the future of street-art? Will it increase LESS DESIGNERS AND PEOPLE /decrease LIKE THAT IT NEEDS MORE LOLIFES X BUM S ARE NEEDED YALLL

>> 5 Things you couldn't live without and why: LONDONPOLICE OBEY THE GIANT KAWS YOMAMMA MUA [runic text] THE HAVENCANGERS

>> Things you don't like: POLITIXXX BY ANY MEANS STOP THAT SHEEET, BILDEBERG - THUGS, STARVATION, TELL SELLE ARE DEMONS. LOCKHEAD MULTINATIONA IS IN GENERAL

>> Any advise? STEAL THIS BOOK

Beta is β

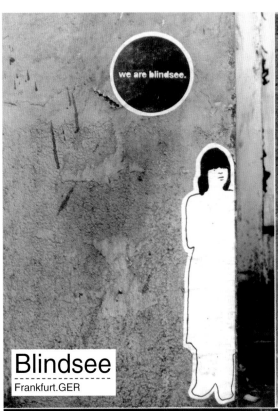

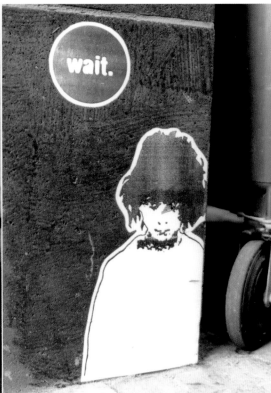

Blindsee
Frankfurt.GER

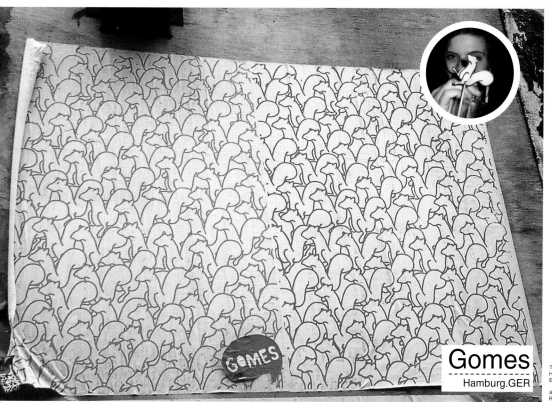

Gomes
Hamburg.GER

>> Name HELLO ITS GOMES

>> Age I'M 24 NOW

>> Hometown HAMBURG

>> Cities where to find your art: PARIS LONDON BARCELONA BERLIN

>> How did you come up with your character? Do you have a visual message? I'M A DRAWER, YEARS AGO A SQUIRREL SAT NEXT TO ME AND IT WAS LIKE » HI GOMES « AND I SAID » HI HOERNCHEN «. WE BECAME FRIENDS, AND WE REACT ON

>> How did you get into street art and when? THINGS WE LOVE | HATE | UNDERSTAND | DON'T UNDERSTAND, WE GIVE ANSWERS TO PEOPLE WHO HAVE TO ENDURE THE DAILY GRAPHIC SHIT ON THE STREETS.

>> Other street artists you admire / respect and why? THE OTHER PART OF MY WORK, THE GOMES WORK, IS ABOUT DRAWING... I LIKE ALL MY FRIENDS, GRAFFITILOVESYOU FOR THE DAY IN DAY OUT COFFEE, ALEXONE, BILD, MILK, FLYING-FORTRESS, STIRB, ANKH

>> Other interests: STAK, SAOR, YOONKEE, HEROIN, BLINDSEE AND THE BIG BLUES I TAKE CARE FOR MY SMALL LOUSY LIVINCOMPANY ITS ABOUT DRAWING & GRAPHIC ON TSHIRTS. ITS AN EDITION THING.

>> How does a typical day in your life look like? WAKE UP, SWITCH MY APPLE ON AND READ SOME NEWS, BREAKFAST, DEAL WITH SOME TASKS, WORK ON THINGS AND DRAW

>> Inspirations: ARE COMMING FROM THE STREETS | TRAVELS | FRIENDS | WWW & MUSIC

>> Favorite music? PUNK ROCK & HEAVY METAL

>> Did you ever get in trouble as a streetartist and what happened? NOT REALLY BIG TROUBLE, BUT I OFTEN GET INTO DISCUSSES WITH PEOPLE ON THE STREETS. ITS EXCITING TO EXCHANGE VIEWS. ITS VERY VALUABLE EVEN THOUGH THERE ARE A LOT OF DISAGREEMENTS.

>> What do you think is the future of street art? Will it increase/decrease? I THINK MORE PEOPLE WILL WORK ON/IN THE STREETS, AND I REALLY HOPE THE QUALITY OF THE WORK WILL INCREASE. NOT ALL THE THINGS IN THE STREETS IS ART, ONLY A PRETTY SMALL PART OF PERSONS WHO WORK OUTSIDE ARE »ARTISTS« I THINK. FUCK YOUR FAME

>> 5 Things you couldn't live without and why: I HOPE PEOPLE WHO PUT THEIR WORK OUTSIDE THINK MORE ABOUT MESSAGES, CITES AND CONNECT THEIR WORK TO CONTEMPORARY THINKS, ARTIST, THINKERS. MORE GAAPHIC COMPREHENSION IS VERY NECESSARY & IMPORTANT. HELLO HERE I AM, I HAVE A SPRAYCAN AND MY NAME IS IS BORINGAND IRRELEVANT.

>> Things you don't like: LOVE: MYFAMILY&FRIENDS, DRAWING, TRAVELLING, APPLE DON'T LIKE: SUGAR IN COFFEE, NUTELLA, BENDED CAPS,

>> Any advise? SORRY I FORGOT SOME PEOPLE & FRIENDS ABOVE, VISIT HAMBURG AND TAKE IT EASY

Graffitilovesyou

Hamburg.GER

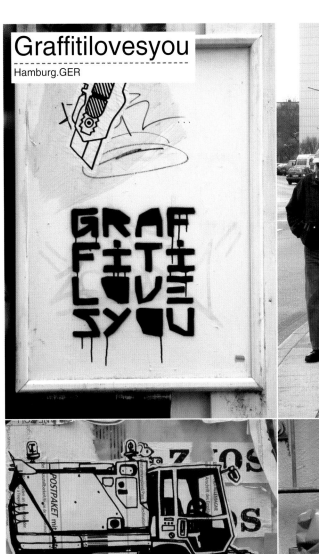

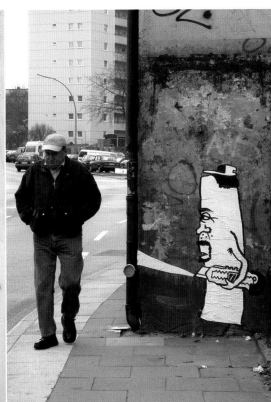

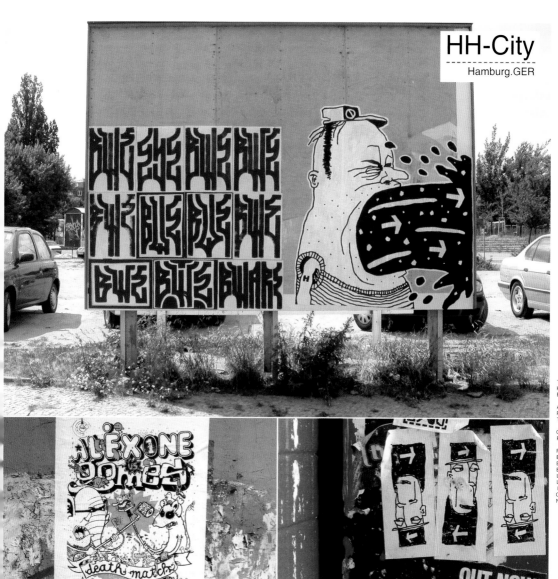

THE ART OF REBELLION

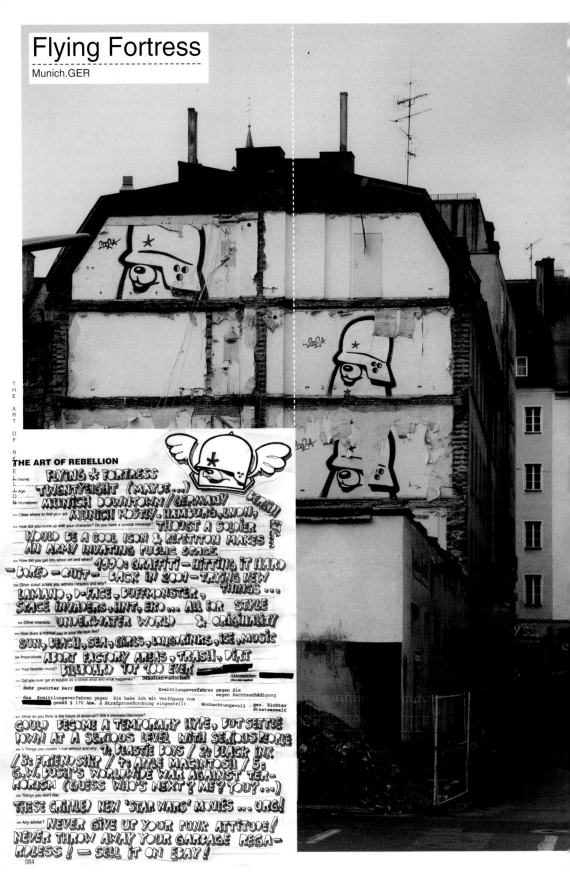

Flying Fortress

Munich.GER

THE ART OF REBELLION

>> Name: FLYING ✦ FORTRESS

>> Age: TWENTYEIGHT (MAYBE...)

>> Hometown: MUNICH DOWNTOWN / GERMANY

>> Cities where to find your art: MUNICH MOSTLY, HAMBURG, LNDN, BERLIN

>> How did you come up with your character? Do you have a special message? THOUGT A SOLDIER WOULD BE A COOL ICON & REPETITON MAKES AN ARMY INVADING PUBLIC SPACE

>> How did you get into street art and when? 1990s: GRAFFITI - HITTING IT HARD - BORED - QUIT - BACK IN 2001 - TRYING NEW THINGS ...

>> Other street artists you admire / respect and why? LAMANO, D-FACE, BUFFMONSTER, SPACE INVADERS, HNT, EKO ... ALL FOR STYLE & ORIGINALITY

>> Other interests: UNDERWATER WORLD

>> How does a tropical day in your life look like? SUN, BEACH, SEA, GIRLS, LONGDRINKS, ICE, MUSIC

>> Inspirations: ABORT FACTORY AREAS, TRASH, DIRT

>> Your favorite music? BILLBOARD TOP 100 EVER

>> Did you ever get in trouble as a street artist and what happened?

Staatsanwaltschaft

Aktenzeichen:
(Bitte stets angeben)

Sehr geehrter Herr ▮▮▮▮▮

Ermittlungsverfahren gegen Sie
wegen Sachbeschädigung

das Ermittlungsverfahren gegen Sie habe ich mit Verfügung vom ▮▮▮▮▮ gemäß § 170 Abs. 2 Strafprozeßordnung eingestellt.

Hochachtungsvoll
gez. Richter
Staatsanwalt

>> What do you think is the future of street art? Will it increase / decrease? COULD BECOME A TEMPORARY HYPE, BUT SETTLE DOWN AT A SERIOUS LEVEL WITH SERIOUS PEOPLE

>> 5 Things you couldn't live without and why 1: BEASTIE BOYS / 2: BLACK INK / 3: FRIENDSHIP / 4: APPLE MACINTOSH / 5: G.W. BUSH'S WORLDWIDE WAR AGAINST TERRORISM (GUESS WHO'S NEXT? ME? YOU?...)

>> Things you don't like: THESE CRIPPLED NEW 'STAR WARS' MOVIES ... URG!

>> Any advise? NEVER GIVE UP YOUR PUNK ATTITUDE! NEVER THROW AWAY YOUR GARBAGE REGARDLESS! — SELL IT ON EBAY!

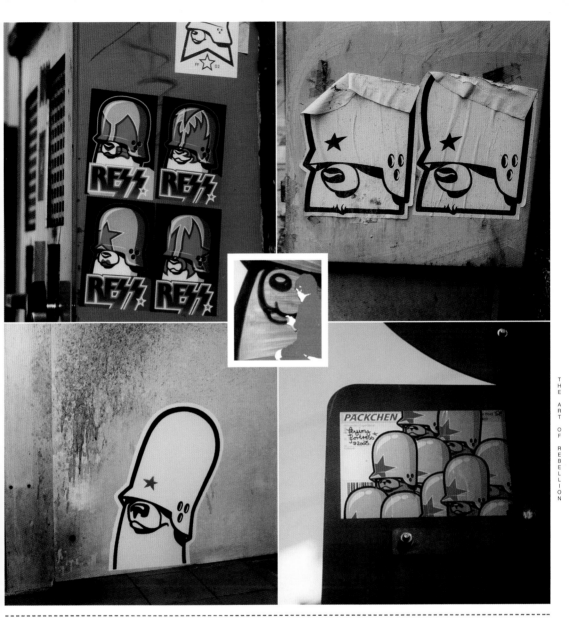

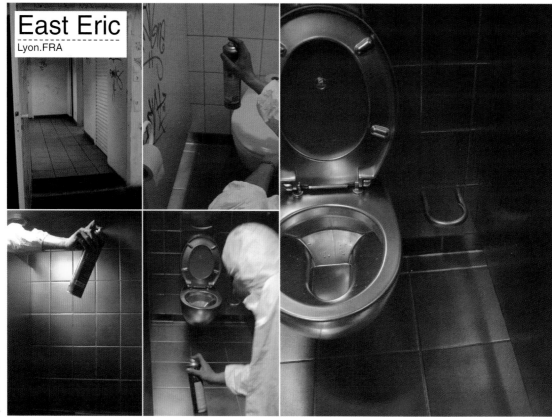

East Eric
Lyon.FRA

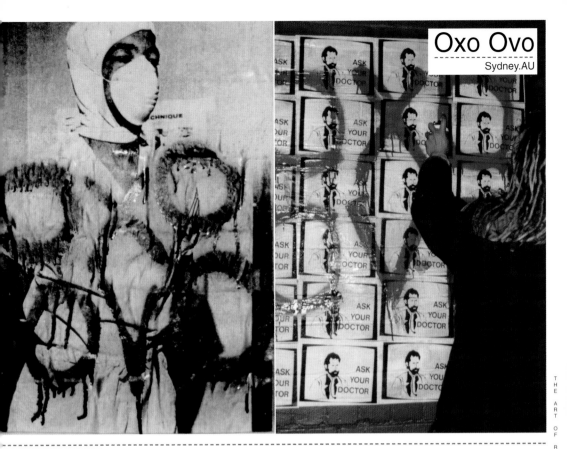

ESM-ARTIFICAL
JUICY STICKERS
SINCE 1991

赤羽会館
kabane Hall

防署
re Department

羽郵便局
kabane Post Office

THERE
IS A
BEAUTY
HERE.

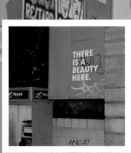

poplab pop

esm
esm
ESM
ESM
poplab poplab
'2001

esm
esm
ESM
ESM
poplab poplab
RE/TARD '2001

http://www.esm-artificial.com/

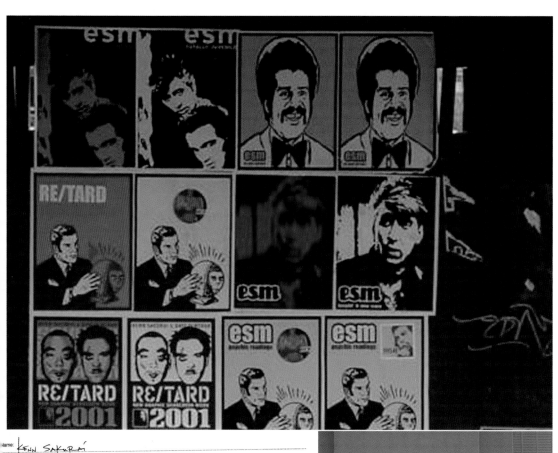

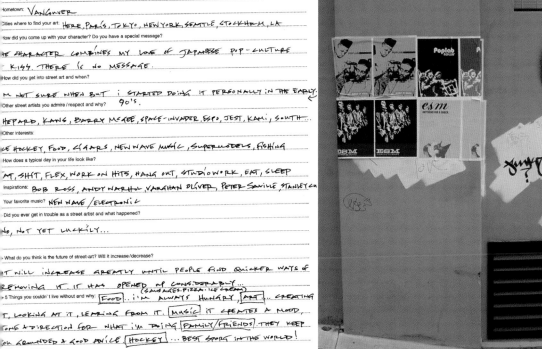

Name: KENN SAKURAI

Age: 34

Hometown: VANCOUVER

Cities where to find your art: HERE, PARIS, TOKYO, NEW YORK, SEATTLE, STOCKHOLM, LA

How did you come up with your character? Do you have a special message?

THE CHARACTER COMBINES MY LOVE OF JAPANESE POP-CULTURE + KISS. THERE IS NO MESSAGE.

How did you get into street art and when?

I'M NOT SURE WHEN BUT i STARTED DOiNG iT PERSONALLY iN THE EARLY 90'S.

Other street artists you admire / respect and why?

SHEPARD, KAWS, BARRY McGEE, SPACE-INVADER, ESPO, JEST, KAMI, SOUTH...

Other interests:

ICE HOCKEY, FOOD, CLAMPS, NEW WAVE MUSiC, SUPERMODELS, FiSHiNG

How does a typical day in your life look like?

EAT, SHiT, FLEX, WORK ON HiTS, HANG OUT, STUDiO WORK, EAT, SLEEP

Inspirations: BOB ROSS, ANDY WARHOL, VAUGHAN OLIVER, PETER SAViLLE, STANLEY CH...

Your favorite music? NEW WAVE / ELECTRONiC

Did you ever get in trouble as a street artist and what happened?

NO, NOT YET LUCKiLY...

> What do you think is the future of street-art? Will it increase/decrease?

iT WiLL iNCREASE GREATLY UNTiL PEOPLE FiND QUiCKER WAYS OF REMOViNG iT. iT HAS OPENED UP CONSiDERABLY...

> 5 Things you couldn't live without and why: [FOOD]...i'M ALWAYS HUNGRY, (SAUSAGES, PIZZA, ICE CREAM) [ART]... CREATiNG iT, LOOKiNG AT iT, LEARNiNG FROM iT. [MUSiC] iT CREATES A MOOD, TONE & DiRECTiON FOR WHAT i'M DOiNG [FAMiLY/FRiENDS] THEY KEEP ME GROUNDED & GOOD ADViCE [HOCKEY]... BEST SPORT iN THE WORLD!

> Things you don't like:

ARTSY CHUMPS, PEOPLE WHO DON'T STAND FOR ANYTHiNG... BEETS

> Any advise? REPRESENT YOURSELF... REPRESENT SOMETHiNG.

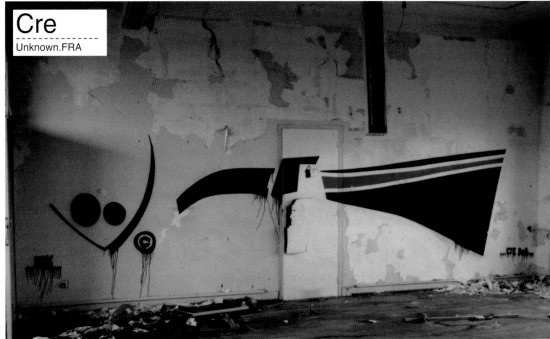

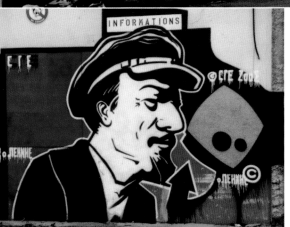

"THE REBEL OF ART"

"...CLINT EASTWOOD..."

>> Name: *cre*
>> Age: *born in 1975 !!!*
>> Hometown: *France*
>> Cities where to find your art: *...Search to find...*

>> How did you come up with your character? Do you have a special message?

YES ! ☺

"...Capitalism"

"...C. BRONSON..."

>> How did you get into street art and when? *...1991 after a report on Graffiti... the beginning of the end...*

>> Other street artists you admire/respect and why? *I don't admire the others street artists but I respect all of them!*

"...S. STALLONE..."

>> Other interests *Hollywood, Fetish sex, Night clubbing, Wars in the world, TV programs, money...*

>> How does a typical day in your life look like? *...like everybody, I eat, I work, I kill a girl in a wood and I go home*

>> Inspirations *Bret easton Ellis, Rauschenberg, USA TV...*

"...CRE..."

>> Your favorite music? *♥ Britney Spears ♥ & Christina Aguilera ♥*

>> Did you ever get in trouble as a street artist and what happened?

NO! ...NOTHING...

"...THE LAW IS THE LAW..." ©

>> What do you think is the future of street-art? Will it increase/decrease? *More repression... More graffiti... More problem... A beautiful fucking world !!!*

>> 5 Things you couldn't live without and why

"...THE CONCEPT OF UNIVERSAL BEAUTY..."

① My eyes to see the beauty ② My hands to touch the beauty ③ My tongue to lick the beauty ④ My ears to listen the beauty ⑤ and ... My dick ...

>> Things you don't like *...Me... My life...*

MY LIFE IS GREAT ©

>> Any advise? *...Stop the graffiti Now !!! ...it's illegal !!! ...don't do it...*

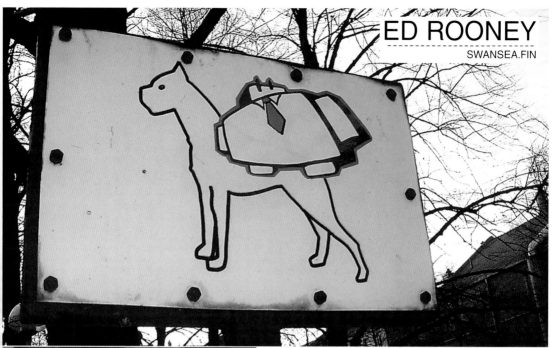

>> Name: SION AKA MRS / Mrs Thomas / ED ROONEY

>> Age: 24

>> Hometown: SWANSEA

>> Cities where to find your art: SWANSEA, LAHTI, HELSINKI, STOCKHOLM

>> How did you come up with your character? Do you have a special message?

WORKING TOO MANY SHIT JOBS DROVE ME TO IT!

>> How did you get into street art and when? GOT INTO IT LAST WEEK BECAUSE ALL THE COOL KIDS DO IT

>> Other street artists you admire / respect and why?

ABSOLUTN'WOLF (SUPER FUNNY STUFF) + ANYONE WHO PUTS SOME THOUGHT INTO

>> Other interests: DESIGN + VISUALS FOR BMEDIAGROUP.NET / MEEK US COLLECTIVE...... AND SOME OTHER STUFF

>> How does a typical day in your life look like?

STARE AT A COMPUTER SCREEN ALL DAY

>> Inspirations:

>> Your favorite music? MR STOPHE + ALL THE WELSH HIP-HOP HEADZ

>> Did you ever get in trouble as a street artist and what happened?

IN SCHOOL, I DREW A BIG DICK WITH A TEACHERS NAME UNDER IT! GOT CAUGHT BY THAT SAME TEACHER (MORE CAREFULL NOW)

>> What do you think is the future of street-art? Will it increase/decrease?

LESS CRAP + MORE QUALITY? LETS HOPE. MAYBE THE "HARDCORE" PAINTERS WILL LIGHTEN UP?

>> 5 Things you couldn't live without and why:

MY NEXT 5 BEERS 'COS IM A THIRSTY BOY

>> Things you don't like: TRENDY "ROCKER" CHICKS, WHO AREN'T OLD ENOUGH TO REMEMBER WHO MAIDEN ARE

>> Any advise? DONT LISTEN TO ANYTHING I HAVE TO SAY

Seven Nine
Sidney.AU

Santy
Unknown.POR

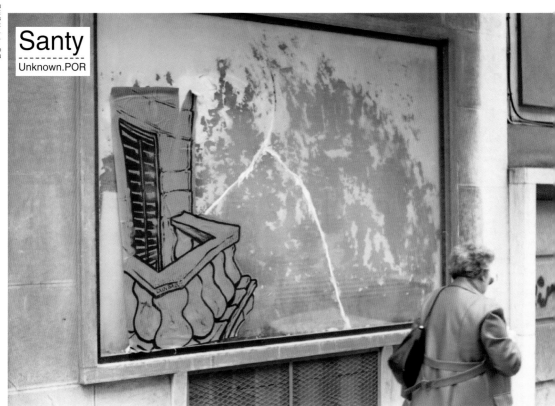

http://seven-nine.net/

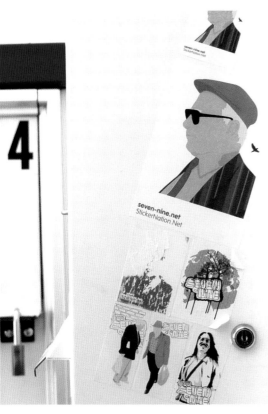

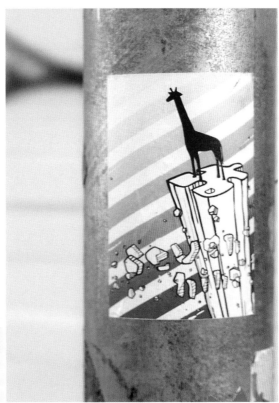

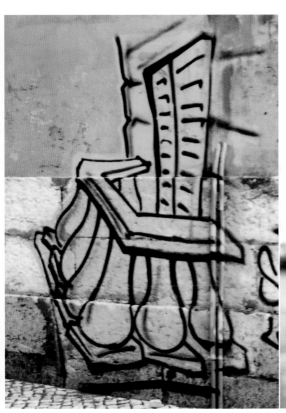

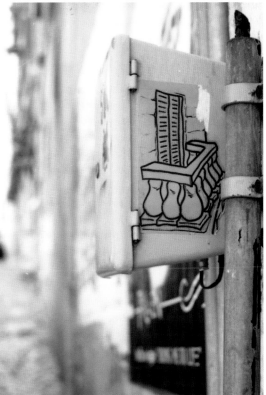

Luna

Norrtelje.SWE

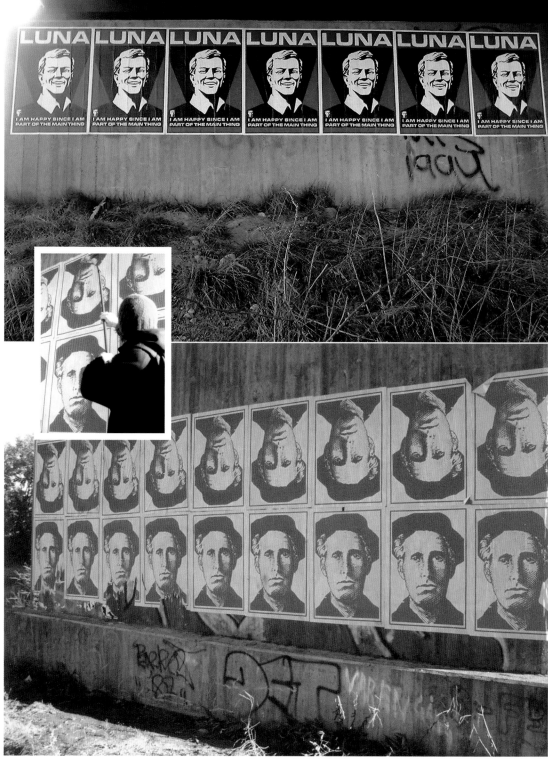

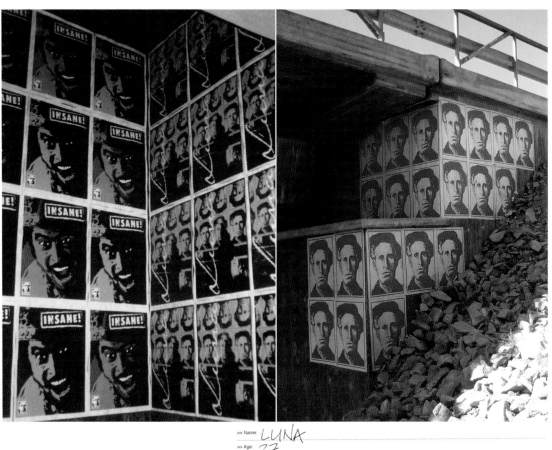

>> Name: LUNA

>> Age: 27

>> Hometown: NORRTELJE, SWEDEN (HELL ON EARTH!)

>> Cities where to find your art: MOST MAJOR CITIES IN SWEDEN, NYC

>> How did you come up with your character? Do you have a special message? I CHOSE JOE HILL BECAUSE HE DID SOME GREAT THINGS DURING HIS LIFETIME. I WANT TO SHOW THAT THE PUBLIC SPACES ARE MEANT FOR US, THE PUBLIC! USE THE PUBLIC SPACES!!

>> How did you get into street art and when? AS I MENTIONED ABOVE, I WANTED (AND STILL WANT...) TO USE THE PUBLIC SPACES FOR SOMETHING CREATIVE. IT WAS FOUR YEARS AGO I THINK.

>> Other street artists you admire / respect and why? BANKSY, DAVE KINSEY, AKAY & ADAMS. THEY HAVE GOOD IDEAS AND MAKE ORIGINAL STUFF.

>> Other interests: ART, MUSIC, DESIGN.

>> How does a typical day in your life look like? WAKE UP, GO TO WORK. HANG OUT WITH SOME FRIENDS. DESIGN SOMETHING. PASTE SOME SHIT IF I'M NOT TOO TIRED.

>> Inspirations: ART, PEOPLE, MUSIC, ANGER, POLITICS, LIFE.... EVERYTHING I GUESS.

>> Your favorite music? THE ONE FROM GLASGOW, UMEÅ, CHICAGO OR NEBRASKA...

>> Did you ever get in trouble as a street artist and what happened?

NO, I'VE BEEN LUCKY SO FAR. (KNOCK ON WOOD...)

>> What do you think is the future of street-art? Will it increase/decrease? IT WILL DEFINITELY INCREASE, THAT'S FOR SURE. I HOPE THE FUTURE WILL BRING MORE ORIGINAL STREETART STUFF THAT NO ONE HAS DONE BEFORE.

>> 5 Things you couldn' t live without and why: MUSIC, IT MAKES ME HAPPY. MY GIRLFRIEND, SHE MAKES ME HAPPY. MY FRIENDS, THEY'RE THE BEST. SUMMER, THE BEST TIME. ART, IT'S BEAUTIFUL.

>> Things you don't like: PREJUDICE, IGNORANT PEOPLE, RIGHT-WING STUPID DUMBASSES. THERE'S LOTS MORE BUT NOT ENOUGH SPACE...

>> Any advise? STAY CALM. USE SOME FUCKING COMMON SENSE. DO YOUR OWN THING NO MATTER WHAT ANYONE ELSE SAYS.

Microbo & Bo130

Milano.I

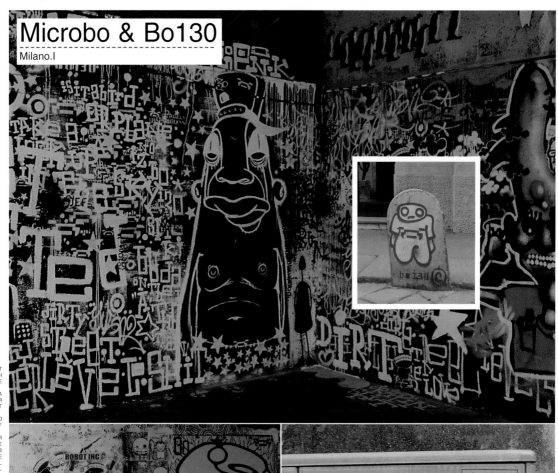

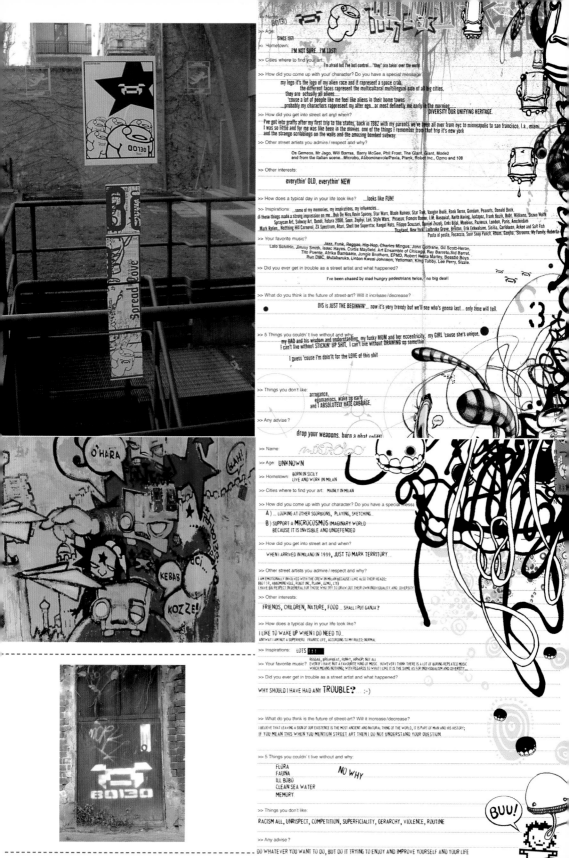

>> Name: BO130

>> Age: SINCE 1971

>> Hometown: I'M NOT SURE...I'M LOST!

>> Cities where to find your art? I'm afraid but I've lost control... "they" are takin' over the world

>> How did you come up with your character? Do you have a special message?
my logo it's the logo of my alien race and it represent a space crab,
the different faces represent the multicultural multilingual side of all big cities,
they are actually all aliens....
'couse a lot of people like me feel like aliens in their home towns
probably my characters rappresent my alter ego...or most definetly me early in the morning.
DIVERSITY OUR UNIFYING HERITAGE.

>> How did you get into street art and when?
I've got into graffs after my first trip to the states, back in 1982 with my parents we've been all over from nyc to minneapolis to san francisco, l.a., miami......
I was so little and for me was like heen in the movies. one of the things I remember from that trip it's new york
and the strange scribblings on the walls and the amazing bombed subway.

>> Other street artists you admire / respect and why?
Os Gemeos, Mr Jago, Will Barras, Barry McGee, Phil Frost, The Giant, Giant, Mode2
and from the italian scene...Microbo, Abbominevole/Pavia, Plank, Robot inc., Ozmo and 108

>> Other interests:
everythin' OLD, everythin' NEW

>> How does a typical day in your life look like? ...looks like FUN!

>> Inspirations: ...some of my memories, my inspirations, my influences...
all these things made a strong impression on me...Bob De Niro,Kevin Spacey, Star Wars, Blade Runner, Star Trek, Vaughn Bodè, Rank Xerox, Gundam, Peanuts, Donald Duck,
Seen, Zephyr, Lee, Style Wars, Picasso, Francis Bacon, J.M. Basquiat, Keith Haring, Juxtapoz, Frank Kozik, Robt. Williams, Shawn Wolfe
Spraycan Art, Subway Art, Dondi, Futura 2000, Seen, Zephyr, Lee, Style Wars, Picasso, Francis Bacon, J.M. Basquiat, Keith Haring, Juxtapoz, Frank Kozik, Robt. Williams, Shawn Wolfe
Mark Ryden... Notthing Hill Carnival, ZX Spectrum, Atari, Shell the Superstar, Kangal Hats, Filippo Scozzari, Daniel Zezeli, Enki Bilal, Moebius, Pazienza, London, Paris, Amsterdam
Thayland, New York, Ladbroke Grove, Brixton, Erik Enkwalsine, Sicilia, Caribbean, Ackee and Salt Fish
Pasta al pesto, Focaccia, Sour Saag Punch, Rhum, Ganjha, 'Shrooms, My Family, Roberta

>> Your favorite music?
Jazz, Funk, Reggae, Hip-Hop, Charles Mingus, John Coltrane, Gil Scott-Heron,
Lalo Schifrin, Jimmy Smith, Isaac Hayes, Curtis Mayfield, Art Ensemble of Chicago, Ray Barreto,Sid Barret,
Tito Puente, Afrika Bambaata, Jungle Brothers, EPMD, Robert Nesta Marley, Beastie Boys,
Run DMC, Mutabaruka, Linton Kwesi Johnson, Yelloman, King Tubby, Lee Perry, Sizzle.

>> Did you ever get in trouble as a street artist and what happened?
I've been chased by mad hungry pedestrians twice, no big deal!

>> What do you think is the future of street-art? Will it increase/decrease?
BIS IS JUST THE BEGINNIN'... now it's very trendy but we'll see who's gonna last... only time will tell.

>> 5 Things you couldn't live without and why:
my DAD and his wisdom and understanding, my funky MUM and her eccentricity, my GIRL 'couse she's unique,
I can't live without STICKIN' UP SHIT, I can't live without DRAWING up somethin
I guess 'cause I'm doin'it for the LOVE of this shit!

>> Things you don't like:
arrogance,
egomaniacs, wake up early
and I ABSOLUTELY HATE CABBAGE.

>> Any advise?
drop your weapons, burn a phat spliff!

>> Name: MICROBO

>> Age: UNKNOWN

>> Hometown: BORN IN SICILY
LIVE AND WORK IN MILAN

>> Cities where to find your art: MAINLY IN MILAN

>> How did you come up with your character? Do you have a special message?
A) ... LOOKING AT OTHER SCORPIONS, PLAYING, SKETCHING.
B) SUPPORT a MICROCOSMOS IMAGINARY WORLD
BECAUSE IT IS INVISIBLE AND UNDEFENDED

>> How did you get into street art and when?
WHEN I ARRIVED IN MILANO IN 1999, JUST TO MARK TERRITORY...

>> Other street artists you admire / respect and why?
I AM EMOTIONALLY INVOLVED WITH THE CREW IN MILAN BECAUSE I LIKE ALSO THEIR HEADS:
BO130, ABBOMINEVOLE, ROBOT INC, PLANK, OZMO, LX)
I HAVE BIG RESPECT IN GENERAL FOR THOSE WHO TRY TO DRAW OUT THEIR OWN INDIVIDUALITY AND DIVERSITY

>> Other interests:
FRIENDS, CHILDREN, NATURE, FOOD ... SHALL I PUT GANJA?

>> How does a typical day in your life look like?
I LIKE TO WAKE UP WHEN I DO NEED TO...
ANYWAY I AM NOT A SUPERHERO. FRANTIC LIFE, ACCORDING TO MY RULES: NORMAL

>> Inspirations: LOTS !!!

>> Your favorite music? REGGAE, BREAKBEAT, FUNK*, HIPHOP; NOT ALL
EVEN IF I HAVE NOT A FAVOURITE KIND OF MUSIC. HOWEVER I THINK THERE IS A LOT OF BORING REPEATED MUSIC
WHICH MEANS NOTHING, WITH REGARDS TO WHAT I LIKE IT IS THE SAME AS FOR INDIVIDUALISM AND DIVERSITY...

>> Did you ever get in trouble as a street artist and what happened?
WHY SHOULD I HAVE HAD ANY TROUBLE? :-)

>> What do you think is the future of street-art? Will it increase/decrease?
I BELIEVE THAT LEAVING A SIGN OF OUR EXISTENCE IS THE MOST ANCIENT AND NATURAL THING OF THE WORLD; IT IS PART OF MAN AND HIS HISTORY;
IF YOU MEAN THIS WHEN YOU MENTION STREET ART THEN I DO NOT UNDERSTAND YOUR QUESTION

>> 5 Things you couldn't live without and why:
FLORA
FAUNA NO WHY
ILL BOBO
CLEAN SEA WATER
MEMORY

>> Things you don't like:
RACISM ALL, UNRISPECT, COMPETITION, SUPERFICIALITY, GERARCHY, VIOLENCE, ROUTINE

>> Any advise?
DO WHATEVER YOU WANT TO DO, BUT DO IT TRYING TO ENJOY AND IMPROVE YOURSELF AND YOUR LIFE

Viagrafik
Wiesbaden.GER

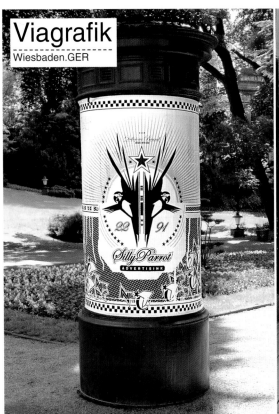

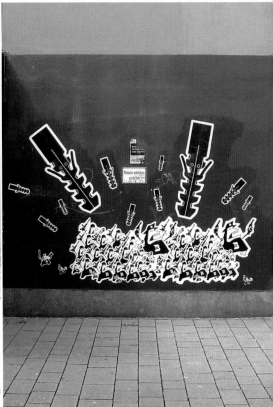

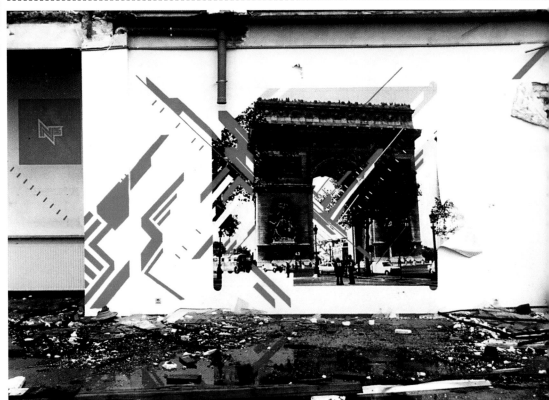

http://viagrafik.de/

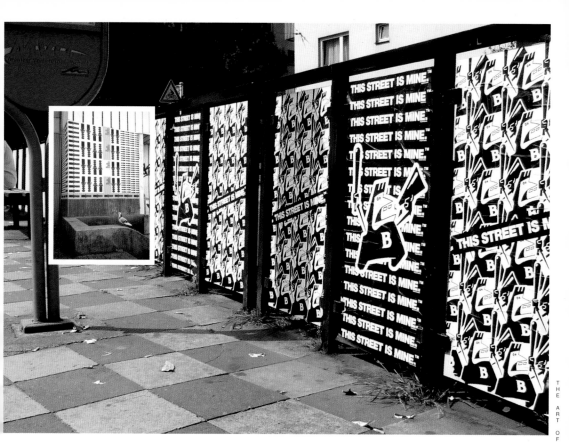

THE ART OF REBELLION

>> Name: GEIST13, SIGN, N6, BOE/BSTRKT, MNWRKS/SLAVE

>> Age: 27, 26, 28, 29, 28

>> Hometown: WIESBADEN, MAINZ GERMANY/WORLD

>> Cities where to find your art: TOO MUCH TO MENTION ALL

>> How did you come up with your character? Do you have a special message?
BSTRKT: IT WAS THE IDEA OF FOUNDING SORT
OF A COMPANY THAT OFFERS STUPID THINGS
AND TAKES WHATEVER IT WANTS. THE USE OF THE
GRAPHICAL LANGUAGE OF COMPANIES FOR YOUR OWN
PURPOSE. MESSAGE: PERSONAL PROTEST

G13: SOMETIMES I FEEL LIKE A GHOST WALKING
THROUGH LIFE

SLAVE: WE ARE ALL SLAVES, IT'S THAT EASY
BUT DO WE REALLY WANNA BE SLAVES?

SIGN: LEAVING INDIVIDUAL SIGNS

N6: PROPAGANDA FOR A ONEEYED ROBOT CALLED
HERBERT. DRAWING OF A SELFMADE PLASTICMODEL

>> How did you get into street art and when? MOST OF US USED TO BE GRAFFITI-PAINTERS SINCE MORE THAN 10
YEARS AND WE GOT MORE INTO POSTING OUR GRAPHICS AFTER THE URBAN DISCIPLINE 2002, WHERE
WE MET SOME OF THE PROTAGONISTS. THOUGH MNWRKS STARTED UP IN THE MID 90'S WHEN HE SAW THE
FIRST POSTERS OF GIANT.

>> Other street artists you admire/respect and why? BLEK LE RAT (BECAUSE HE MADE SUCH BIG STENCILS), GIANT (BECAUSE HE GOT ME INVOLVED INTO
THE WHOLE THING), WK INTERACT(BEAUTYFUL!), BANKSY (FOR STENCILING LIKE SHIT-FOR HIS
STRAIGHTNESS AND THE BALANCING OF COMMERCIAL ASPECTS), JOHN YATES (BECAUSE HIS POSTERS JUST
ROCK!, 61666)

>> Other interests: SLAVE: PHILOSOPHY, MAKING MUSIC/NOISE, SCREAMING, BOOKS, NATURE, THINKING ABOUT UTOPIA.
SIGN: YES N6: TO BUILD-CONSTRUCT, MOTION GRAPHICS, ARCHITECTURE G13: MUSIC, TO LET THINGS MOVE (ON THE SCREEN)
SPINNING AROUND
BSTRKT: BUILDING, CREATING, RELAXING, SNOWBOARDING, HOW THINGS WORK IN NATURE.

>> How does a typical day in your life look like?
DREAMING, FORMALITIES, DREAMING, BUILDING & CREATING & DREAMING, RELAXING & REFLECTING, SPINNING
AROUND, GOING OUTSIDE, DREAMING, RELAXING, SLEEPING, DREAMING
DRINKING, SMOKING, EATING, SLEEPING, WORKING, HAVING FUN, FIGHTING AND
OFTEN COMBINING THESE THINGS IN DIFFERENT ORDERS AND WEIGHTING. DREAMING
GETTING UP, BREAKFAST, DRIVING TO THE ATELIER, THINKING & DESIGNING, CREATING & DESTROYING, LISTEN TO MUSIC, DESIGNING,
RELAXING & EATING, HANG OUT WITH FRIENDS, MEETING THE STREETS, SLEEPING.

>> Inspirations: J. MÜLLER-BROCKMANN, DADA & RAOUL HAUSMANN, SITUATIONISTEN, NIETZSCHE, SARTRE, ANIS NIN, GEORG BÜCHNER,
REFUSED, ORCHID, BLADERUNNER, SIENCE-FICTION, CHAOS/ORDER, LOVE/HATE, VARIETY OF HUMANS, DELTA, ZEOZ-INC-CREW,
MAGIC, RCB, KHC, MIKE YOUNG, KARL MARX, LOOTPACK, PAUL'S BOUTIQUE, GUNDAM, MORPHOSIS, Z. HADIO, COOP HIMMELBLAU,

TOR & IAN ANDERSON, EIKESGRAFISCHERHORT, C. SCHLIENGENSIEF, WIM CROUWEL, K.P. WILLBERG, SQUAREPUSHER, CONVERGE,

>> Your favorite music? GILLIAMS, BRAZIL, MK12, DEJOE, BURO DESTRUCT, LUCA IONESCU, MONTY PYTHON, THE ATTIK, AUTECHRE, POLAR, .

>> Did you ever get in trouble as a street artist and what happened?
SLAVE: SO FAR NOTHING SERIOUS HAPPENED, THE POLICE IS JUST TOO DUMP

>> What do you think is the future of street-art? Will it increase/decrease?
IT WILL INCREASE
IT HAS TO INCREASE...

>> 5 Things you couldn't live without and why. BSTRKT: I COULDN'T LIVE WITHOUT BEING ABLE TO CREATE SOMETHING BECAUSE MY ART IS THE PLACE
I CAN FLEE TO TO DEFINE MY OWN RULES.
SLAVE: MY COMPANIONS IN CRIME, 'CAUSE IT'S NICE NOT TO BE ALONE, MY MACINTOSH, YOU KNOW WHY!?, FRIENDS, FOR CRITIQUE & INSPIRATION, CHAOS,
BECAUSE EVERYTHING AROUND US IS CHAOS.
SIGN: WATER, THE SUN, FOOD, A FLAT, DESIGN N6/G13::
- BECAUSE THESE THINGS ARE THE BASIC STANDARDS MY THIRD LEG FOR GETTING ERECTED, CREATIVITY FOR STAYING FUNKY,
THAT SHOULD BE AVAILABLE FOR EVERYONE! MUSIC FOR HAVING SOULFOOD, HUMOR-FRIENDS FOR FEELING GOOD
MY HEAD - TO THINK, BOTH LEGS TO WALK, HANDS TO CREATE, EYES TO SEE OUR SHITTY FRIENDS

>> Things you don't like: STANDSTILL, AUTOCRATIC BABBLERS, CAPITALISM™, SQUARES, COPS, LIERS,
INTERNATIONAL OPERATING CORPORATIONS, RELIGION & GOD, NARROW MINDED
PEOPLE

>> Any advise ? DO YOUR OWN THING.
CHAOS IS MY CO-PILOT

WE ONLY GOT OUR BOREDOM TO LOSE.

TAKE CARE

Ecce
Sydney.AU

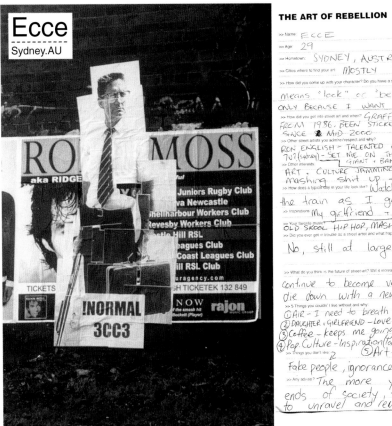

THE ART OF REBELLION

Hope THIS IS U.K.

>> Name: ECCE

>> Age: 29

>> Hometown: SYDNEY, AUSTRALIA.

>> Cities where to find your art: MOSTLY SYDNEY

>> How did you come up with your character? Do you have a special message? ECCE IS latin and
means "look" or "behold", so I CHOSE IT NOT
ONLY BECAUSE I WANT PEOPLE TO LOOK AT MY STUFF
BUT ALSO AS A WAKE UP CALL LIKE "OPEN YOUR FUCKING EYES"

>> How did you get into street art and when? GRAFF HISTORY
FROM 1986. BEEN STICKERING/posters/stencils
SINCE MID 2000

>> Other street artists you admire/respect and why?
RON ENGLISH - TALENTED AND DIVERSE, AMAZING WORK
7UP(sydney) - SET ME ON THE RIGHT PATH
GIANT + BANKSY - CONSISTANCY.

>> Other interests:
ART + CULTURE JAMMING. Anything that involves
mashing shit up for my own amusement.

>> How does a typical day in your life look like? Watch the graff roll by on
the train as I go to my slave wage job.

>> Inspirations: My girlfriend + Daughter, graff + other street artists getting their stuff up

>> Your favorite music: OLD SKOOL HIP HOP, MASHED UP techno with emotion, pop culture

>> Did you ever get in trouble as a street artist and what happened? anything
No, still at large!!!

>> What do you think is the future of street art? Will it increase/decrease? I think it will
continue to become very mainstream but then
die down with a new trend replacing it, but will
have a strong subculture always

>> 5 Things you couldn't live without and why:
① AIR - I need to breath
② DAUGHTER + GIRLFRIEND - Love
③ Coffee - keeps me going
④ Pop Culture - Inspiration (love hate relationship)
⑤ Art - makes life worthwhile.

>> Things you don't like: 2
Fake people, ignorance, greed + vegetables.

>> Any advise? The more you pull at the loose
ends of society the more it will start
to unravel and reveal its true nature.

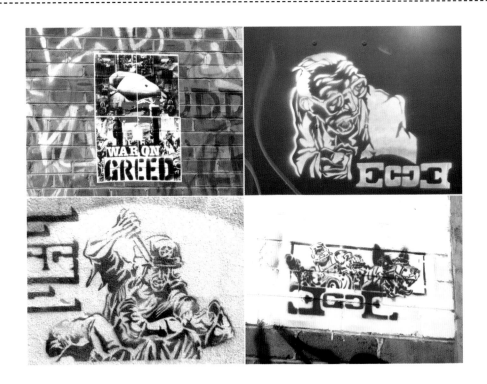

e: CHEBA

: 19

netown: Bristol, England

s where to find your art: BRistol mainly

 did you come up with your character? Do you have a special message? i draw what i see or what pops

into my head and build on it.

 did you get into street art and when? i started making stickers late 01 them got into

stencils, now im making posters.

er street artists you admire/respect and why? sums, sickboy, banksy, above all just

really inspiring.

r interests: skateboarding, music, friends, art

 does a typical day in your life look like? it varies alot

rations: people, citys, tv, internet, cartoons, other artists, music

 favorite music? expermental hip hop

you ever get in trouble as a street artist and what happened? ive come close but its a pretty

fast process, you dont stick around

at do you think is the future of street-art? Will it increase/decrease? hopefully increase, it

looks like its going that way.

ings you couldn´t live without and why: family, friends, skateboarding, art, music

all for obvious reasons.

gs you don't like: theres not alot i dont like

 advise? Use every media possible to get the job done

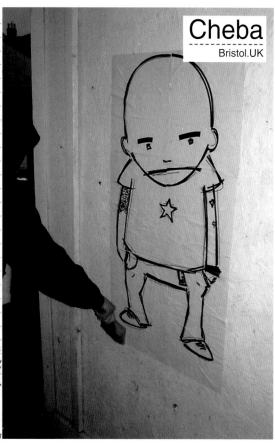

Cheba

Bristol.UK

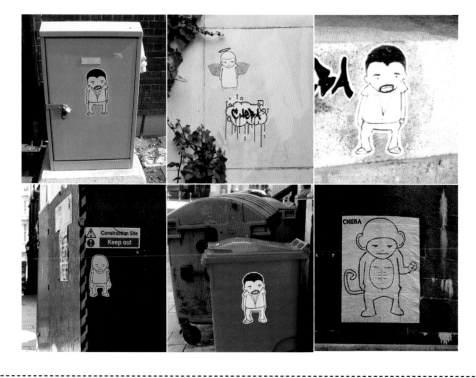

Toasters

London.UK

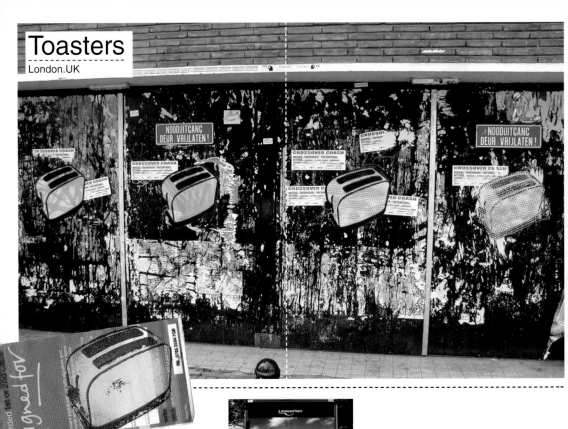

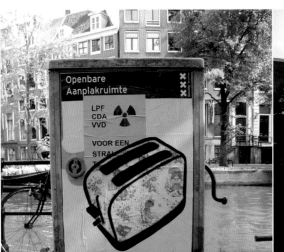

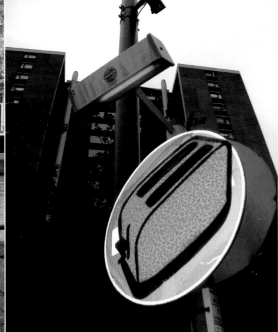

I WANTED TO PAINT SOMETHING THAT STOOD OUT, AN ICON THAT I COULD USE AS A BRANDING FOR MY STYLE, AT THE TIME I WAS INTERESTED IN ARCHITECTURAL SPACE AND HOW IT AFFECTS US. AFTER SEEING SOME BEAUTIFUL PARTS OF EUROPE, WITH SOME INCREDIBLE BUILDINGS, I WAS BROUGHT BACK DOWN TO EARTH UPON MY RETURN TO THE U.K. WITH ITS DRAB SKYLINES FILLED WITH GREY CONCRETE MONSTROSITIES. I DECIDED TO USE A TEMPLE OR ONIONDOME AS A SYMBOL TO REPRESENT WHAT I BELIEVED TO BE INSPIRING ARCHITECTURE THAT I HAD RECENTLY SEEN IN SPAIN AS A RESULT OF THE WORK OF GAUDI. I WANTED TO KEEP THE COLOURS CONSTANT RED/YELLOW AS THEY ARE COLOURS THAT MAKE PEOPLE FEEL HAPPY, AND MY GRAFFITI IS NOT MEANT TO BE AGGRESSIVE, I PREFER SUBTELY DROPPING THE MESSAGE ON TO BRITAINS PROUDEST EXAMPLES OF DEPRESSING CONCRETE.

Sickboy
Bristol.UK

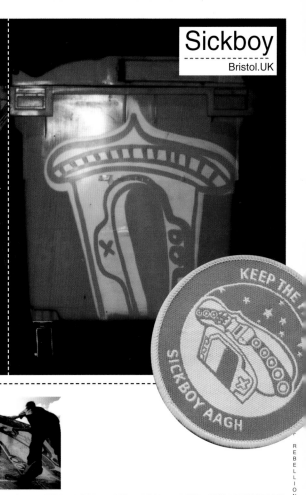

REBELLION

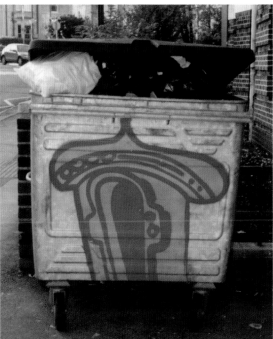

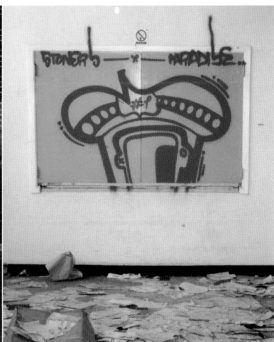

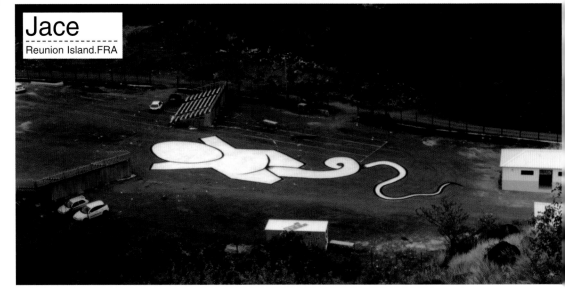

THE ART OF REBELLION

>> Name: JACE

>> Age: 30

>> Hometown: Reunion Island (french island in Indian Ocean)

>> Cities where to find your art: essentially in my island or in le Havre (in France).
Did some also in London, Praha, Roma, Mauritius Island, Indonesia, Lisboa, Paris, Amsterdam...

>> How did you come up with your character? Do you have a special message?
I began painting my character in 92, i was already doing traditional graffitis with letters and characters, spending all my time drawing and painting, but there was nothing really different between me and the others, so i decided to make my own stuff. At the time it wasn't so developped and i was like a paria. A lot of graffiti writer was considering it as shit, but public loved it. No way, I should know was intended for the public, don't care about pretentious!

>> How did you get into street art and when?
I began spray painting in 89 here in Reunion Island, i have always been fascinated by this form of expression, my optional drawing teacher at school got the book "subway art", every week i was absorbed by the pictures, the way of life, the esthetic... present in this graffiti bible.

>> Other street artists you admire / respect and why?

There are so many... Haven't got enough place.

>> Other interests:

Very interesting about every thing,
very open on other cultures. My family, traveling, surfing...

>> How does a typical day in your life look like?
Wake up at 6:30 (father obligation !), then check the mail, either i'm going to work :
i'm a half time drawing teacher since this year, or i'm spending my time drawing, painting or on the computer.

>> Inspirations: Youchhhhhh, so many too ! At the beginning Seen, Mode 2,
Futura, N° 6 ... made me crazy, after then Keith haring gave me a lot.

>> Your favorite music?
Very differents : indian, local, punk, hip-hop, techno, Reggae...I'm very fan of Beastie boys.

>> Did you ever get in trouble as a street artist and what happened?
Sur, of course ! Who can paint during 14 years in the street without having trouble with the law?.
One of my worst souvenir with justice was in 99 in New york City getting caught by the cop on a saturday afternoon on broadway (searching for it) ! I was beginning a gouzou (it's my character name) when a civil cop caught me... i spent 30 hours in jail. They didn't want to liberate me cause they couldn't find the wall owner. They wanted to keep me in jail til they find it. I wasn't able to come back in France. Fortunately my barrister defended my problem with the judge very well, then i could get off that shit where no human right was respected.

>> What do you think is the future of street-art? Will it increase/decrease?

Future of street-art... ? The present is very positive, a lot of creation is doing everywhere on earth. As we say in french "la machine est en marche".

>> 5 Things you couldn't live without and why:

My family cause they are a part of me and made me move forward, some spray cans (is it necessary to say more ?), my computer (to communicate with the exterior), beers (to keep my fat belly), my glasses (i'm totally blind without it).

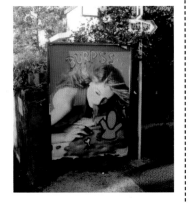

>> Things you don't like:

drops falling from a roof on my head

>> Any advise ?

"don't worry, be happy !" could be a good one for me.

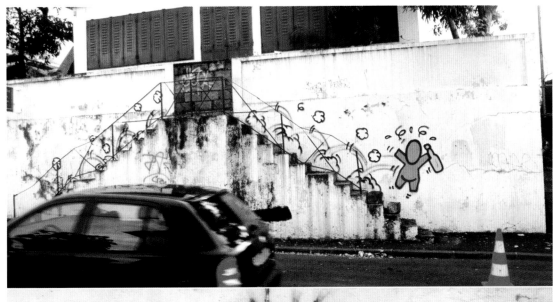

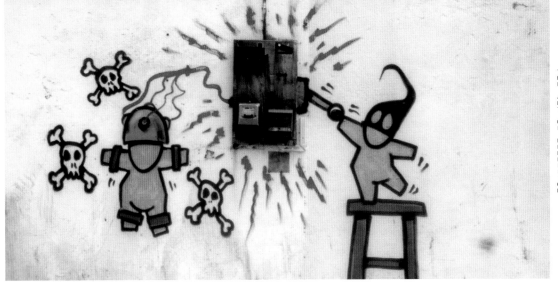

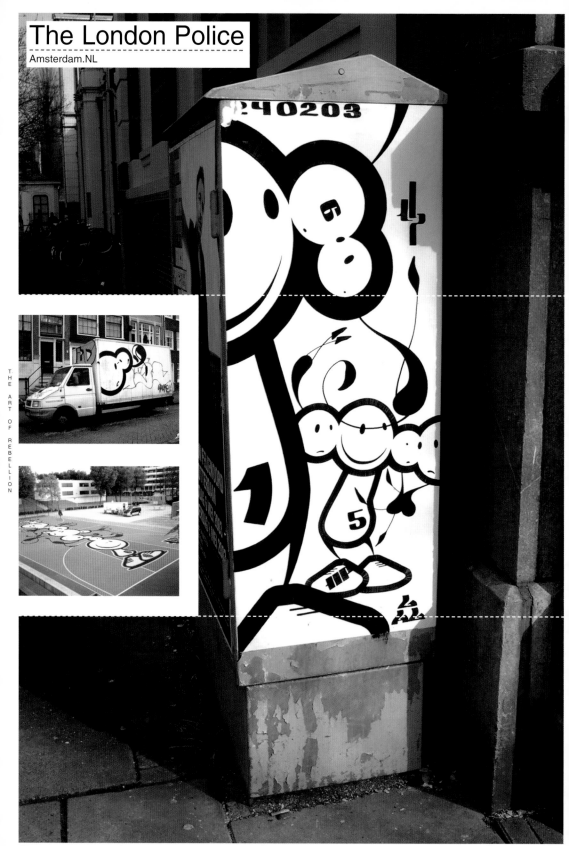

http://www.thelondonpolice.com/

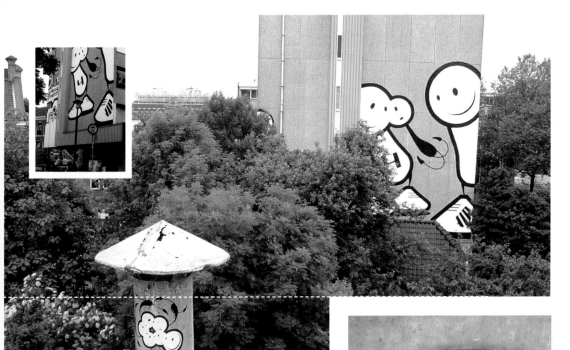

> COUNTRY: ENSCHEDE NL

we are the
london police. we were
all twelve, once. we were born
in london and san francisco. we've
lived in amsterdam for the past 4 years.
our characters, the lads were born on beermats
in bars across europe. so far, lads have found
homes in amsterdam, of course; rotterdam; breda
antwerp; brussels; berlin; copenhagen; milano;
torino; fiorenza; barcelona; new york; san francisco;
portland; tokyo; osaka... our message is free smiles
for anyone willing to lend us an eye. we've been
involved with some aspect of street art for most
of our lives –tagging, writing, stickers... we've
been working together as the london police
for almost four years now. we have time
for anyone who puts their work on the
street with conviction, spirit, love
and regularity. we spend most
of our time working on llp
projects. otherwise we are
sleeping. most days we're work-
ing on paintings or projects
throughout the day. our nights
are spent working on the street.
we are inspired most by traveling
to new places, meeting new people,
and feeling new energies. there is
something so nice about entering a
new city; scoping all the works native
to that city, looking for the best spots
to get up work on and leaving a bit
of ourselves behind. we are stop-
ped by the police all the time
however, our convictions and
passion for our art

(and a good set of walkie-talkies)
means that we have managed to steer clear
of any time spent in jailcells. most police are pretty reason-
able if you explain to them what you do. we feel that a populist
and democratic approach to art is the future of art itself. this selfsame
thought is what makes street art itself so appealing. as people become ever
more familiar with the language of the medium, it's our hope that interest in it
will similarly grow. this trend is evidenced in the advertising world's embrace
of the culture. floss your teeth. smile. breathe. love is
the answer.

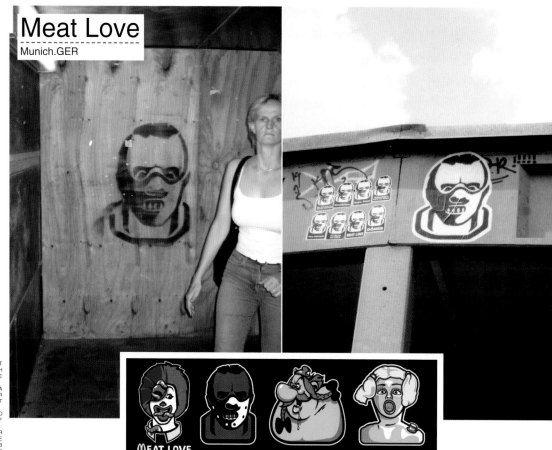

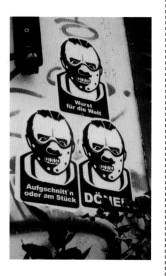

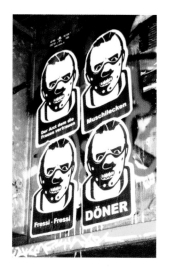

THE ART OF REBELLION

>> Name: Meat Love

>> Age: Me and my maggots are altogether 100 years old

>> Hometown: Munich

>> Cities where to find your art: Sin-Cities

>> How did you come up with your character? Do you have a special message? Restless night

You shouldn't run after the life that someone else told you how to live

>> How did you get into street art and when? Munich was calling for it 2 years ago!

>> Other street artists you admire / respect and why? I admire those who stay consequent

>> Other interests: -----

>> How does a typical day in your life look like? Ask the undercover cops

>> Inspirations: The German satire-magazine "Titanic" and the daily newspaper "BILD"

>> Your favorite music? Meat Loaf

>> Did you ever get in trouble as a street artist and what happened?

Nothing because they don't see it as an art!

>> What do you think is the future of street-art? Will it increase/decrease?

I hope that also outstanding people will jump on the train.......would be cool!

>> 5 Things you couldn't live without and why:

To handle things in an ironic, sarcastic, ill, cryptic and black way of humour

>> Things you don't like:

Loud and strident humans

>> Any advise?

Have you seen me?

T
H
E

A
R
T

O
F

R
E
B
E
L
L
I
O
N

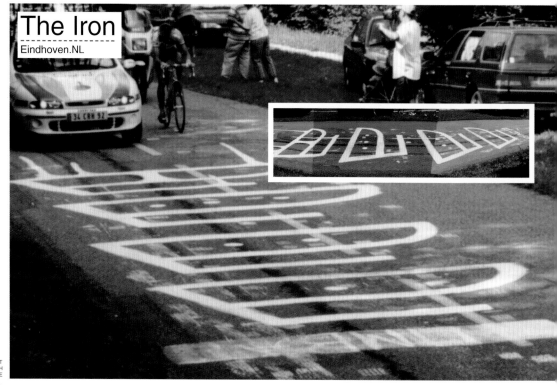

The Iron
Eindhoven.NL

Stain & Scout
Baltimore.USA

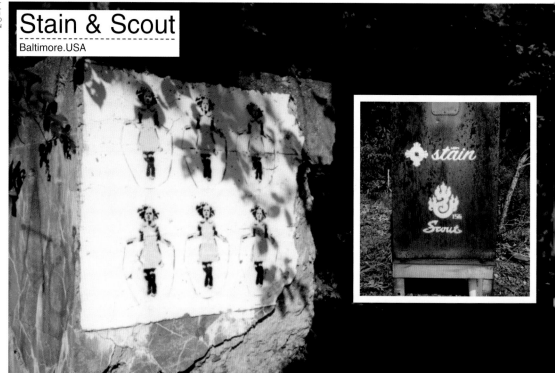

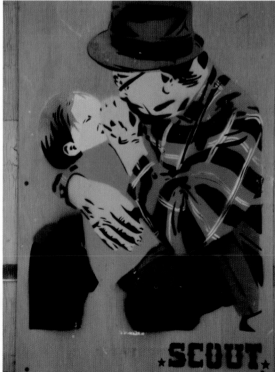

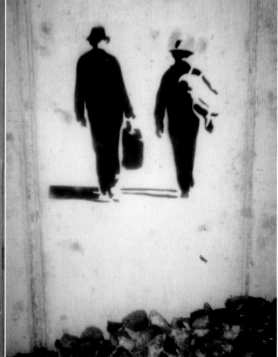

Ambrio/KRSN/Akroe
Unknown.FRA

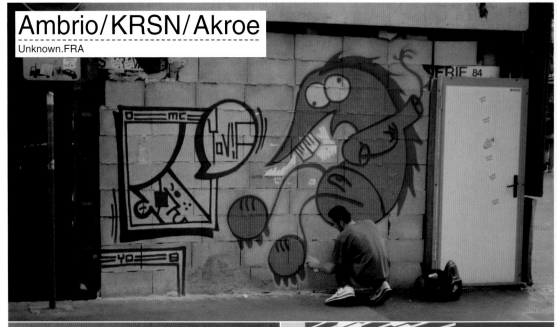

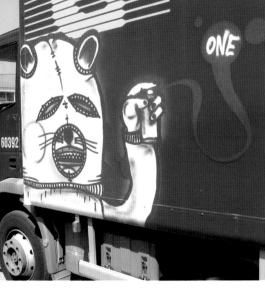

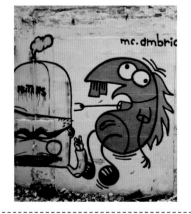

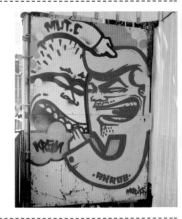

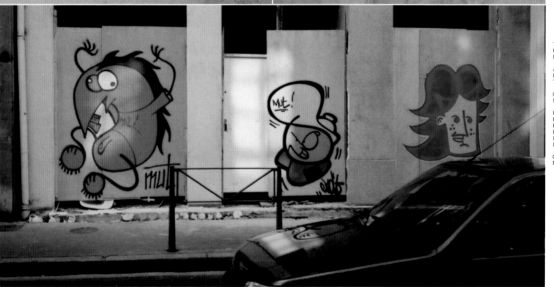

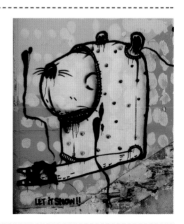

W/Remote

St. Paul.USA

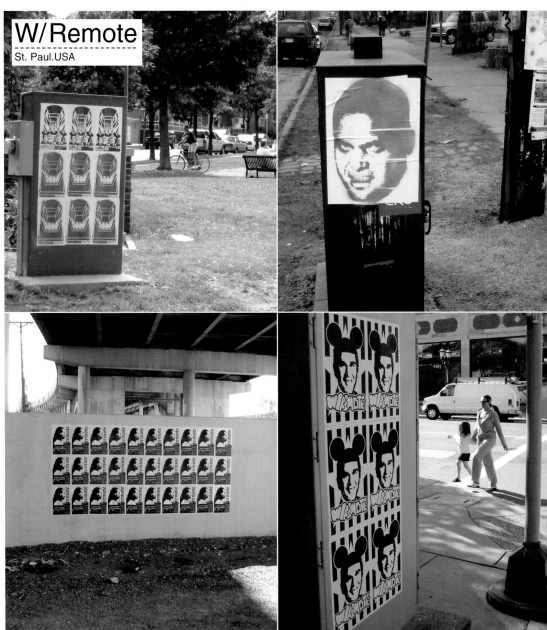

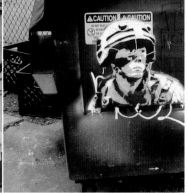

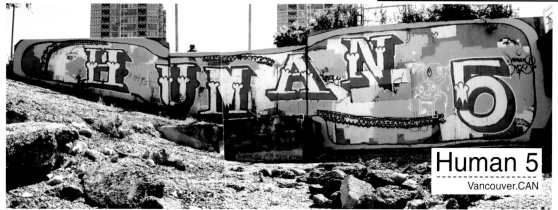

Human 5

Vancouver.CAN

>> Name: HUMAN FIVE

>> Age: 25-26

>> Hometown: DAWSON CREEK, WINNIPEG, KIMBERLEY (CANADA)

>> Cities where to find your art: VANCOUVER, MINNEAPOLIS, DENVER, NEW YORK, VICTORIA

>> How did you come up with your character? Do you have a special message? WE PAINT AND PUT CHARACTERS UP. ~~WITH DRILLS AND NAILS AT TIMES~~ WE GIVE THEM COMFORTABLE, SUITABLE HOMES WITHIN CITIES.

>> How did you get into street art and when? STARTED GRAFFITI IN 96 AND FROM THERE WERE INSPIRED TO PUSH FURTHER, EXPERIMENT WITH NEW WAYS. ~~STREET ART~~

>> Other street artists you admire / respect and why? GEMEOS, KGBE, BACTERIA, KE GR TWIST FAILE

>> Other interests: MUSIC, FOOD, EXERCISE, ~~WATER~~

>> How does a typical day in your life look like? BREAKFAST (COFFEE), EMAIL, BIKE RIDE AROUND WALL, CHILL, PAINT, BOOKSTORE, DINNER, FILM, MORE PAINTING, READ, B...

>> Inspirations: HUNDERTWASSER, PEOPLE, ANIMALS, IMPERFECTIONS

>> Your favorite music? THE SEA AND CAKE, BOARDS OF CANADA, PREFUSE 73, RAPPERS

>> Did you ever get in trouble as a street artist and what happened? 5 days JAIL TIME *

>> What do you think is the future of street-art? Will it increase/decrease? WILL REMAIN CONSISTENT, MORE ENFORCEMENT = MORE ART, RECLAIMING PUBLIC SPACE

>> 5 Things you couldn't live without and why: WATER, MUSIC, ~~ART SUPPLIES~~, LOVE HEALTHY FOOD SWANZEES (so cute and cozy.)

>> Things you don't like: EGOS, FRONTING, NAME DROPPING, LOUD, ~~BUSH?~~ = WAR

>> Any advise? PERSISTENCE, SUBTLETY, GIVE CREDIT WHERE CREDIT IS DUE... EAT LOTS OF FRUIT EVERYDAY.

THE ART OF REBELLION

THE ART OF REBELLION

JUST LOGO, NO CONCEPT.

SPACE3 STARTED AT THE ACADEMIE IN S'HERTOGENBOSCH IN 1994, A GRAPHIC DESIGNER AND AN ILLUSTRATOR TEAMED UP TO DO A POSTER FOR A FRIEND WHO WAS A DJ. THE COLLABORATION WORKED OUT VERY WELL. WE KNEW EACH OTHER ALREADY FROM THE TEEN DAYS WHERE ONE OF US HANGED OUT IN THE GRAFFITI SCENE AND THE OTHER TRIED TO ENTER IT. WE MET AGAIN SEVERAL YEARS LATER AT THE ART ACADEMY AND DID SOME TAGGING TOGETHER IN THE STREETS OF EINDHOVEN. WE WERE NOT SO GOOD, BUT WE BOTH KNEW WE WERE GREAT ON TYPE AND IMAGE ON GRAPHICLY SPEAKIN TERMS. SO AFTER THE FIRST COLLABORATION FOR THE DJ WE STARTED SPACE3, AFTER HANGING OUT IN OUR JOINT SKETCHIN AND DRAWING ROOM, LISTENING TO „THE ULTRAMAGNETIC MC'S" AND HEARING KOOL KEITH'S „WE ARE THE HORSEMEN ENTER YOUR SPACESHIP" AND A GRAPHIC SIMPLIFIED UFO ENTERED THE MONITOR ON THE ILLUSTRATOR 5 WINDOW. WE MADE A LOGO WITH THE SPACESHIPS AND A NEW SPACE3-TYPE. LATER IT GOT JUMBO EARS SO IT COULD FLY AND GET GLOBAL. THE GRAPHIC DESIGNER STARTED HIS OWN PRACTICE WHILE THE ILLUSTRATOR JOINED A POST GRADUATE STUDY ON GRAPHIC DESIGN. IN BETWEEN OUR COMMISSIONED WORK WE WANTED TO MAKE THE STREETS OF OUR CITY VISUAL MORE ATTRACTIVE, WE HATED THE BIG SPENDED MONEY ADVERTISEMENT CAMPAIGNS WITH NO VISUAL SATISFYING EFFECT AND THEIR ONLY GOAL TO SELL SOMETHING. SPACE3 WANTED TO ENRICH THE STREETS WITH GRAPHICS THAT WERE NEVER SEEN BEFORE, A VISUAL RIDDELE WITH NO ANSWER. WE'VE HEARD A LOT OF COMMENTSON ON OUR GRAPHIC INTERVENTIONS: „WHAT'S THIS CRAZY STUFF? WHO ARE THOSE FOOLS? WHERE DO THEY COME FROM? WHAT THE FUCK DOES IT MEAN? HOW CAN I GET MY HANDS ON SOME POSTERS?" MEANWHILE WE STAYED ANONYMOUS AND WERE HAPPY WITH THAT BECAUSE IT GIVES OUR ACTIONS AND IMAGES MORE POWER. 9 YEARS LATER WE PRACTISE OUR OWN GRAPHIC DESIGN STUDIO. NEXT TO OUR WORK WE STILL DO OUR STREET ACTIONS, MEANING XEROXED OR SCREEN PRINTED PAPER, GLUE AND FITTING SPOTS.

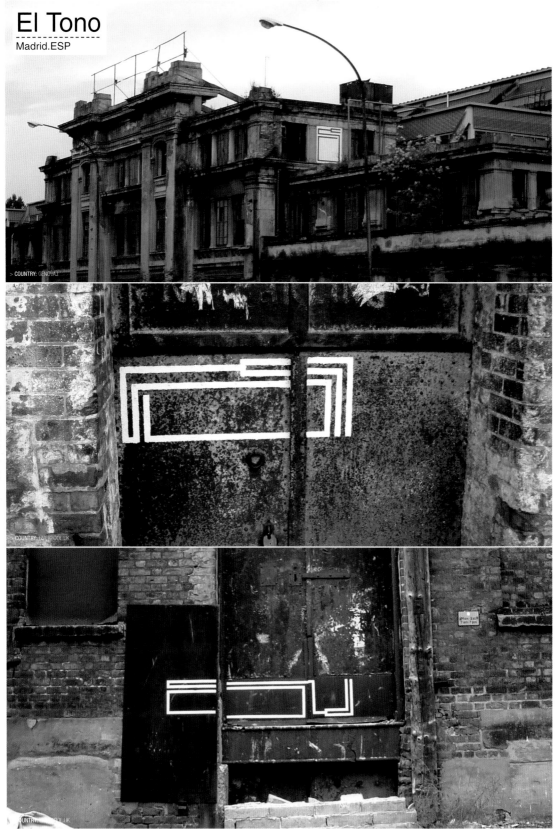

El Tono
Madrid.ESP

> COUNTRY: GENOVA.I

> COUNTRY: LIVERPOOL.UK

> COUNTRY: LIVERPOOL.UK

http://www.eltono.com/

THE ART OF REBELLION

>> Name: **eltono**

>> Age: -

>> Hometown: **Paris, now I'm living in Madrid**

>> Cities where to find your art: **Madrid, Paris, Liverpool, Porto, Glasgow, Genova, Venezia, Modena, Seoul**

>> How did you come up with your character? Do you have a special message?

The form I'm painting is inspired in a tuning fork, the imageinterpretation of my name.

Message: Love and respect your neigbourhood and your city

>> How did you get into street art and when?

in 1999, in Madrid, I wanted to continue working in the street but reaching more people and not only the writers micro-society

>> Other street artists you admire / respect and why?

a lot!

>> Other interests:

-

>> How does a typical day in your life look like?

Graphic design during the day, skateboard in the afternoon, street painting at night!

>> Inspirations: **The cities I'm visiting, the street visual comunication**

>> Your favorite music? **Today: The french rap hit "Aketo Vs Tunisiano"**

>> Did you ever get in trouble as a street artist and what happened?

No...Police is cool with brush painters!

>> What do you think is the future of street-art? Will it increase/decrease?

All urban activities are fashion now, I hope this fashion will end quickly

>> 5 Things you couldn't live without and why:

Nuria, because she's unique, My computer because he helps me a lot,

my skateboard because it makes me feel better and stressless,

an old European city center because it's my favorite canvas and my painting tape!

>> Things you don't like:

People who don't look around, close minded people

>> Any advise?

-

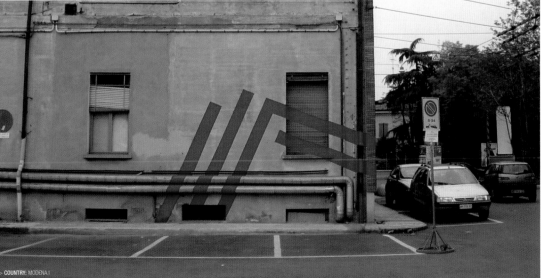

> COUNTRY: MODENA.I

> COUNTRY: MODENA.I

THE ART OF REBELLION

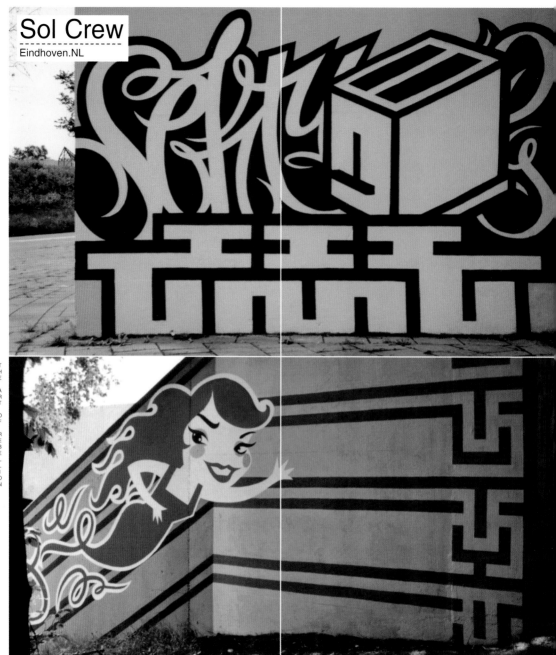

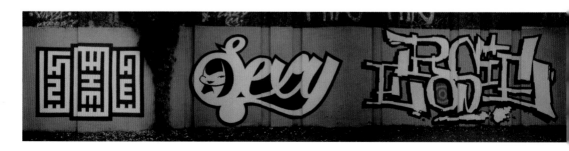

http://www.solcrew.nl/

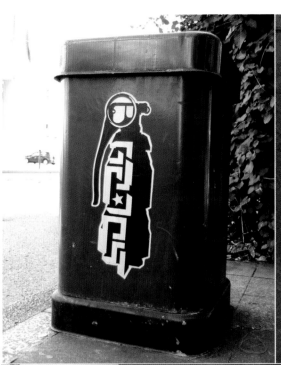

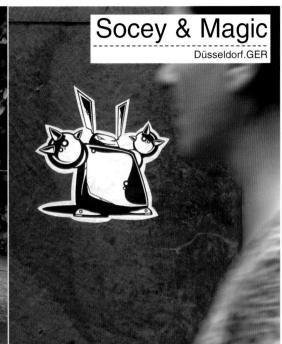

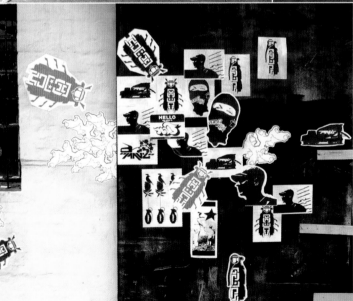

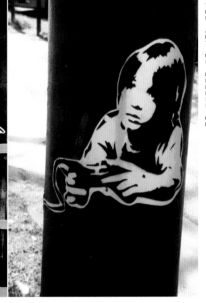

Etron

Unknown.FRA

no webaddress

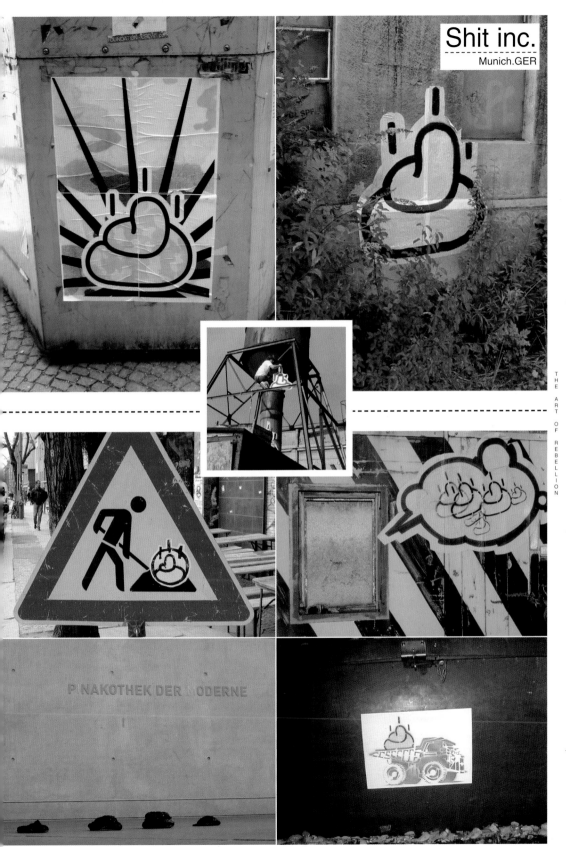

THE ART OF REBELLION

Kami
Tokyo.JAP

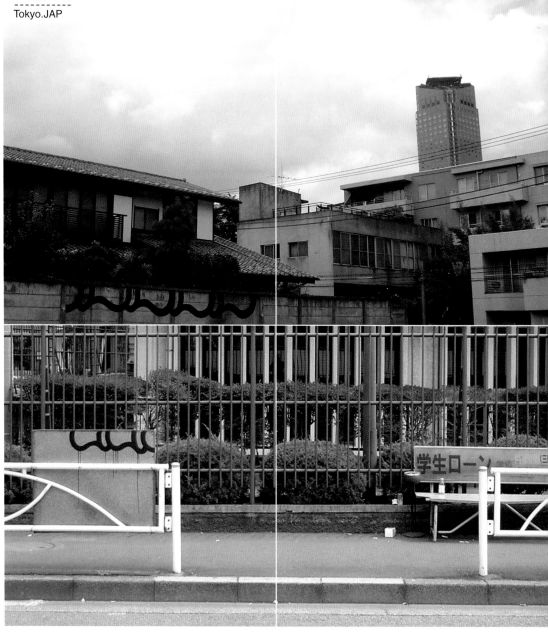

no webaddress

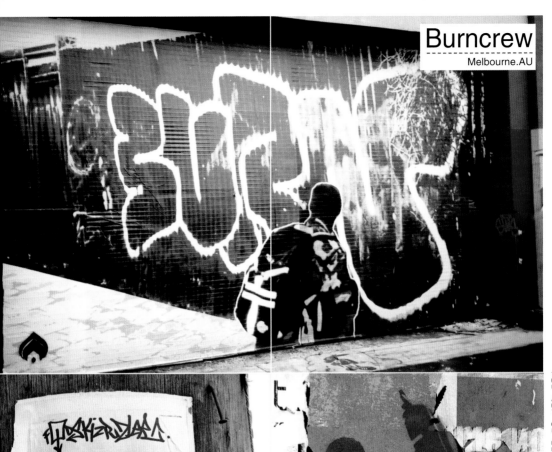

THE ART OF REBELLION

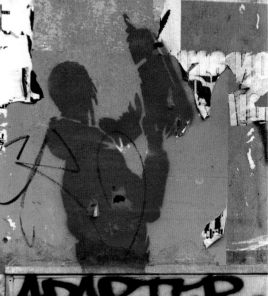

http://burncrew.com/

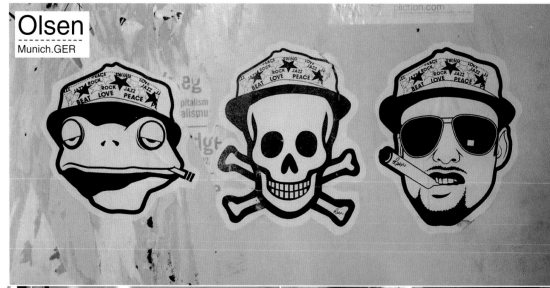

THE ART OF REBELLION

THE ART OF REBELLION

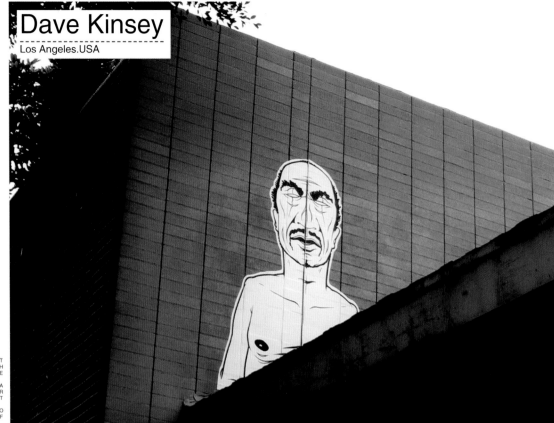

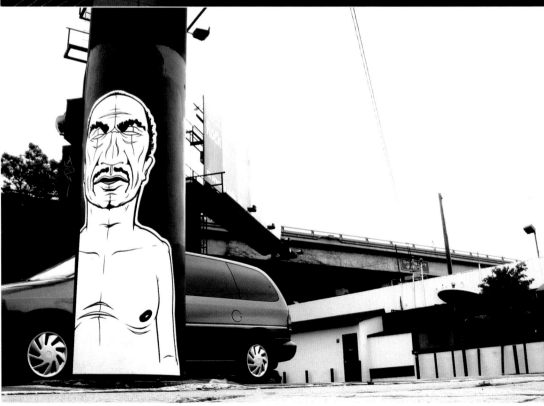

http://www.kinseyvisual.com/

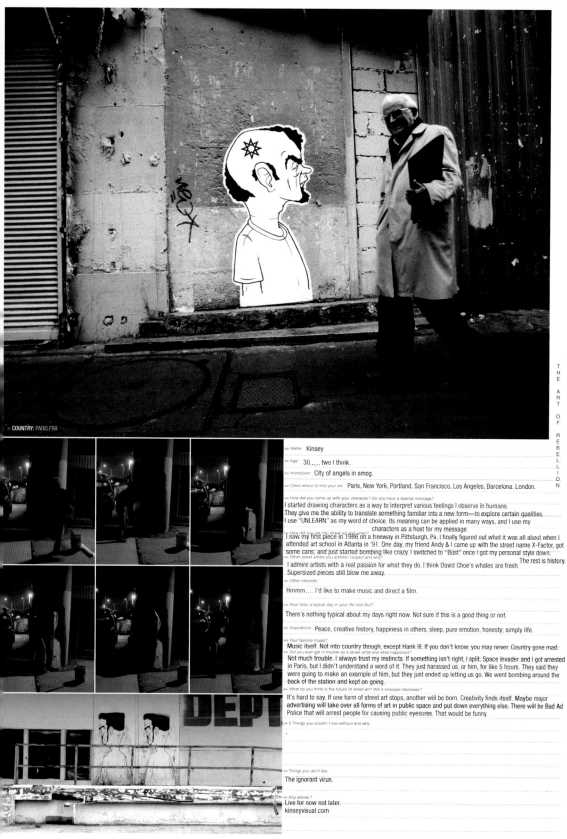

> COUNTRY: PARIS.FRA

>> Name: Kinsey

>> Age: 30,,,,, two I think.

>> Hometown: City of angels in smog.

>> Cities where to find your art: Paris, New York, Portland, San Francisco, Los Angeles, Barcelona. London.

>> How did you come up with your character? Do you have a special message?
I started drawing characters as a way to interpret various feelings I observe in humans.
They give me the ability to translate something familiar into a new form—to explore certain qualities.
I use "UNLEARN" as my word of choice. Its meaning can be applied in many ways, and I use my characters as a host for my message.

>> How did you get into street art anyway when?
I saw my first piece in 1986 on a freeway in Pittsburgh, Pa. I finally figured out what it was all about when I attended art school in Atlanta in '91. One day, my friend Andy & I came up with the street name X-Factor, got some cans, and just started bombing like crazy. I switched to "Büst" once I got my personal style down. The rest is history.

>> Other street artists you admire /respect and why?
I admire artists with a real passion for what they do. I think David Choe's whales are fresh.
Supersized pieces still blow me away.

>> Other interests:
Hmmm.... I'd like to make music and direct a film.

>> How does a typical day in your life look like?
There's nothing typical about my days right now. Not sure if this is a good thing or not.

>> Inspirations: Peace, creative history, happiness in others, sleep, pure emotion, honesty; simply life.

>> Your favorite music?
Music itself. Not into country though, except Hank III. If you don't know, you may never. Country gone mad.

>> Did you ever get in trouble as a street artist and what happened?
Not much trouble. I always trust my instincts. If something isn't right, I split. Space Invader and I got arrested in Paris, but I didn't understand a word of it. They just harassed us, or him, for like 5 hours. They said they were going to make an example of him, but they just ended up letting us go. We went bombing around the back of the station and kept on going.

>> What do you think is the future of street art? Will it increase/decrease?
It's hard to say. If one form of street art stops, another will be born. Creativity finds itself. Maybe major advertising will take over all forms of art in public space and put down everything else. There will be Bad Ad Police that will arrest people for causing public eyesores. That would be funny.

>> 5 Things you couldn't live without and why:
-

>> Things you don't like:
The ignorant virus.

>> Any advice?
Live for now not later.
kinseyvisual.com

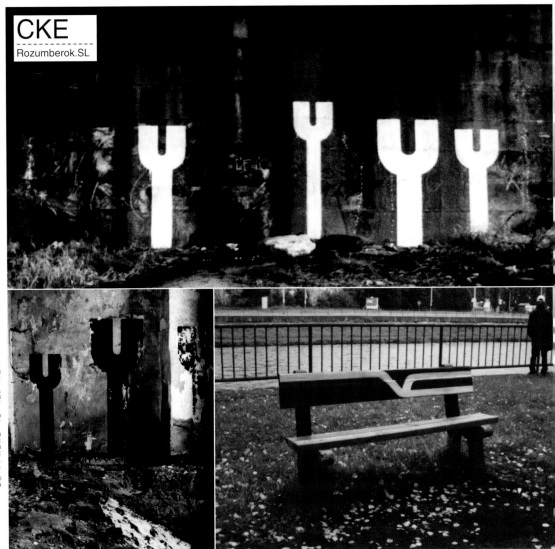

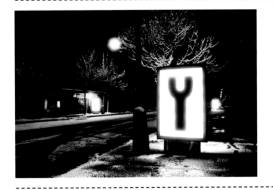

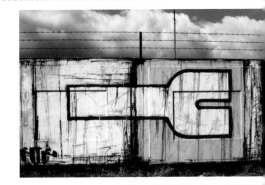

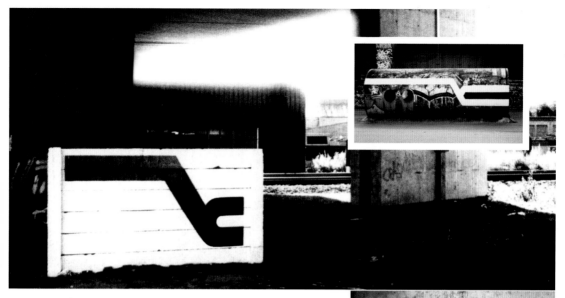

Name: CKE

Age: 20

Hometown: RUZOMBEROK - SLOVAKIA - NORTH

Cities where to find your art: BRATISLAVA PRAHA WARCZAWA PARIS BRUXELLES Stockholm ...

How did you came up with your character?

CKE : CJKE ---> C --> -C C C ⊂ Ƨ ⊑ Y

How did you get into street art and when?

AFTER MEETING WITH STAK + HONET I TURNED FROM GRAFFITI TO STREET ART 2000-01

Other street artists you admire / respect and why?

INVADER, ZEUS, AKAY, OBEY — CREATIVITY + LOT OF WORKS

Other interests: PHOTOGRAPHY, COOKING

How does a typical day in your life look like?

I LIKE TO SLEEP A LOT THAN HURRYING AND BUSY ALL DAY. IN THE EVENING IM WORKING OR MEETING FRIENDS + TELEVISION/COMP

Inspirations? EVERYDAY LIFE, CONTEMPORARY ART + MY FRIEND LENA - MYSLIAVE

Your favourite music? ELECTRO AMBIENT METAL TELESO

Did you ever get in trouble as a street artist?

FEW TIMES, NOTHING REALLY SERIOUS. ONCE I PAYED 150 SKK = 3€ FOR TAINTING THE TRAIN

What do you think is the future of street art?

I THING THE BOOM WILL BE OVER IN A SHORT TIME. LOT OF "TRUE" RITERS WILL STOP, THANK GOD. THE OTHERS WILL HAVE TO GALLERIES

5 Things you couldnt live without and why?

TO ENJOY LIFE I NEED TO HAVE GOODFRIENDS AROUND ME, GIRLFRIEND, ASTY GOOD MEALS, LITTLE OF MONEY, MOBILE PHONE, AND TRAVEL A LOT,

Things you dont like:

HUMAN STUPIDITY, IRRESP. ALSO SUCCESS WITH THE ONSIBILYTY, DRUGS, THERE WORK I DO ! ARE LOT OF THINGS I DONT LIKE TO SEE

Any advice? TRAVEL A LOT, WORK HARD, BE PATIENT FIND YOUR OWN WAY.

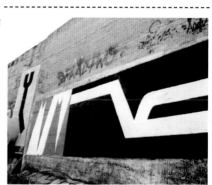

Stickernation

http://www.stickernation.net/

When and why did you start StickerNation.net?

Promoting artists through the medium of stickers started StickerNation back at the turn of the century. The concept let visitors download pre-formatted artwork for printing onto blank sticker paper. This allowed the work to travel places the artists themselves would never go.

After the purchase of a digital camera the site expanded to include a photo archive of stickers whilst on adventures in and around London. The scene was quite small but with some real good artists emerging (Gas & Bed, Instant (D*Face), Solo, Regular Product, Zeel). As people began hearing of the site the Seen and PDF archive began to grow. Friendships were made and the sticker buzz became more intense. After a series of uncontrollable incidents the site was forced to close in September 2001 and we went back to the drawing board. We had created a monster, too much time was required to keep it happy and fed. A new concept letting a global team of members update the site was born and went into production 6 months later. The screens shown here are the fresh result of this idea and we relaunched in April 2003.

Where you are from?

The team of StickerNation members are from across the globe, each representing their home turf. I'm from Manchester UK, although right now I'm living in smokey Amsterdam where there is a fantastic sticker community.

How many people are involved in stickernation and is that is your job or are you just doing it for fun?

StickerNation is maintained by an ever growing community of members, each is encouraged to document their local scene both with news and photos. A core team of 10 contributors look after written features, artist profiles, site maintenance and design. My role is primarily design. As much as we would like the site to be our daily operation we all work for the 'man' elsewhere. The site is done for love but we hope we can change this in the future. Funding will allow us to do bigger and better things although I do see the need to remain true to our original concept.

What problems come along with doing such a website\

Where do I start? There are countless problems in creating a website like StickerNation, from the obvious (design, technical, production) to StickerNation is. Come back each day / week / month and you will see

Respect always go out to people who act on their word. Gas face to those who dismiss others without showing anything themselves.

changes and updates.
The amount of work can be quite overwhelming and v1 of the site closed as it became too much. It was managed by just myself and almost gave me grey hairs... almost! As you can imagine building the new site to include all the new features was incredibly difficult but will make the whole maintenance far easier. It means we can focus on the content and promoting sticky love.
One major oversight became apparent when we relaunched the site and that was traffic and bandwidth. Traffic costs money and within 3 days we'd hit our monthly limit and had to close the site down. 10 months of work potentially wasted. Big shouts go out to Media Temple (www.mediatemple.net) for hosting the site for us. We would have been fucked otherwise.

How is the process in giving birth to such a site?
Just do it! It sounds blaz'\8e but it's really that simple. The web has made projects like StickerNation available to everyone. Don't waste time wondering how and why, just get busy. Anyone who saw the very first release of StickerNation will know how basic and humble a beginning we had.

What is your aim for the future?
StickerNation could go in many directions and right now we're trying to choose the best path. I think as long as we adhere to the reasons why we started then we'll be ok. Promote known and unknown artists; Document street art; Act as a news base for good design, art and illustration; To be inspiring.
We initially focussed on stickering but since we launched the whole notion of what street art can be has changed. It has become quite an exciting time. I think our biggest and fundamental change will be to cover a wider spread of street happenings from stickers to posters to stencils to sculpture. Boundaries are growing and styles influences one another. Artist don't just work in one format anymore, why should we? Ultimately we want to show and share everything we see around us.

Thanks to Dom Murphy

Worldsigns

Magazine

WHO HAS NEVER DREAMT OF THEIR OWN EXHIBITION SPACE? A FLEXIBLE ENVIRONMENT THAT COMES WITHOUT THE FINANCIAL DIFFICULTIES CONNECTED TO A CLASSICAL GALLERY, DESIGNED TO SATISFY THE SPECIFIC DESIRES OF THE ARTIST. WHO HAS NOT LONGED FOR AN INTERNATIONAL STAGE WHICH CAN BE ACCESSED FROM PARIS, LONDON AND TOKYO? WORLDSIGNS© IS THE IDEAL PLATFORM: DUE TO ITS FLEXIBLE NATURE A POSSIBILITY HAS BEEN CREATED TO SUPPORT FAMOUS ARTISTS AND NEWCOMERS IN THE POST-GRAFFITI ERA AND TO INTRODUCE THEM TO THE AUDIENCE. TODAY, THE SMALL BUT FREE SPACE OF WS CONTRIBUTES TO THE ACCEPTANCE OF A MOVEMENT FORMERLY UNAPPRECIATED AND LOOKED DOWN UPON BY THE MAINSTREAM INSTITUTIONS OF ART.

FOR A STRONG MOVEMENT AND THE REAL FUTURE OF ART.

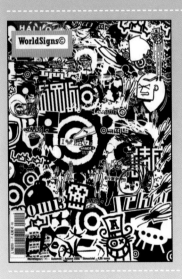

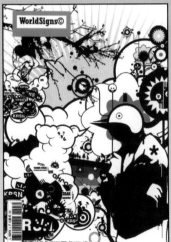

http://www.ws-mag.com/

Ekosystem.org

http://www.ekosystem.org/

„HELLO MY NAME IS EKO! I STARTED RUNNING EKOSYSTEM.ORG IN 1999. I HAD JUST STOPPED MY 10 YEARS GRAFFITI CAREER. IT WAS MORE LIKE A PERSONAL PAGE. THERE WERE SOME OF MY PIECES, PARTY PHOTOS, AND FRIENDS MUSIC TO DOWNLOAD. I QUICKLY ADDED SOME FRIEND PIECES, BECAUSE I LIVE IN SOUTH-WESTERN FRANCE, AND OUR SCENE HADN,T MUCH COVERAGE ON GRAFFITI MAGAZINES, AND I WANTED TO SHOW OUR WORK. I ALSO ADDED PEOPLE I ENJOYED WORK. IN THAT TIME, THEIR PRODUCTIONS WAS SAID TO BE „ECCENTRIC LIKE CHA OR SPACE INVADER. MY FRIEND VEGA CAME AND HELPED ME TO RUN THE WEBSITE. HE TOOK LOT OF TRAINS PHOTOS, CODED A FLASH MENU AND LATER ADDED THE PHP ADMIN SYSTEM. IN THAT TIME ALL THE PHOTOS ON THE WEBSITE WERE OURS. QUICKLY SOME PEOPLE STARTED TO CONTACT US AND SEND US PHOTOS OF NON-HIP-HOP GRAFFITI (PICTOGRAMS, POSTERS, STICKERS) AS WE WERE ONE OF THE ONLY WEBSITE TO PRESENT SUCH GRAFFITI SCENE. NOWADAYS MOST PHOTOS ARE SENT BY FRIENDS AND CONTACTS, IT IS EKOSYSTEM FORCE (WE HAVE PHOTOS FROM ALL OVER THE WORLD) BUT ALSO ITS WEAKNESS (YOU CAN SOMETIME SEE THE SAME WORK ON OTHER WEBSITES).IN THE BEGINNING OF THE WEBSITE, WE REALLY HAD THE FEELING TO PROMOTE UNDERGROUND GRAFFITI THAT WAS APPRECIATE BY A VERY FEW PEOPLE. BUT LAST DAYS I REALLY HAD THE FEELING WE WERE THE NORM AND THE WEBSITE WAS A BIT USELESS. THERE ARE NOW TONS OF WEBSITES WHO PRESENT NEARLY THE SAME PRODS AS US. BUT MANY PEOPLE ASKED ME TO KEEP IT ON, THAT EKOSYSTEM WAS IMPORTANT FOR THEM, AS WE ARE THE BIGGEST GALLERY ABOUT SUCH GRAFFITI ONLINE (THERE WERE ABOUT 5000 PHOTOS IN JULY 03, AND IT,S GROWING EVERYDAY). I,VE FINALLY DECIDED TO KEEP ON RUNNING IT. I MUST ADMIT THAT I STILL ENJOY UPDATING THE WEBSITE, EVEN IF IT IS MANY WORK TO ANSWER MAILS, CUT & UPLOAD PHOTOS. I SPEND AT LEAST ONE HOUR EVERY DAY ON IT. BUT THANKS TO THE WEBSITE MANY PEOPLE MEET EACH OTHER AND COLLABORATE TOGETHER THROUGH IT. I,M ALSO PROUD OF A PROJECT LIKE „DON,T COPY ME‰, IT WAS THE 1ST TIME GRAFFITI ARTISTS FROM DIFFERENT COUNTRIES WORKED TOGETHER ON ILLUSTRATING A COMMON SLOGAN. I CAN SAY I HAVE A BIT CONTRIBUTED TO THE DEVELOPMENT ON THE KIND OF GRAFFITI I LIKE. IT IS A BIT STRANGE THAT A WEBSITE WHICH HAS MOTIVATED SO MUCH PEOPLE TO START MAKING NON-HIP-HOP GRAFFITI COMES FROM A SMALL CITY WHERE STREET LIFE IS QUITE CALM.

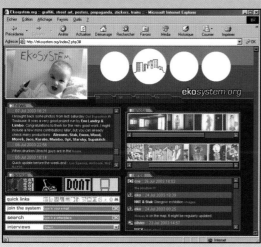

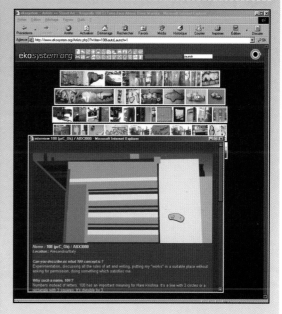

Stickerwar

http://stickerwar.net/

.HEY YOU,
YES YOU. ALL OF YOU. THIS IS STICKERWAR AND
THEY ARE NOW GREEN.

IVO AND PAUL ONCE WENT INTO THE OUTSIDE
WORLD AWAY FROM THEIR COMPUTERS TO GET
SOME FRESH AIR. BUT IT WASNT THERE BECAUSE
EVERYTHING IS FULL OF FUCKING SMOG SO THEY
WENT BACK INSIDE AND STARTED STICKERWAR.
THIS HAPPENED IN THE YEAR 2002 AND HAS GIVEN
THEM A REASON TO GO OUT INTO THIS POLUTED
FUCKED UP ENVIRONMENT. THEY HOPE TO
ENCOURAGE MORE OF YOU TO DO THE SAME.
TO THEIR SUPRISE THERE WAS MORE PEOPLE
DOING THE SAME SHIT, SOME HATE THEM, SOME
JOINED THEM AND SOME DONT EVEN CARE, YET.
PEOPLE FROM ALL OVER THE WORLD HAVE JOINED
THE WAR. THEY DONT REALLY CARE IF YOU LIKE
THEM OR DONT, JOIN OR FIGHT BECAUSE .SW. AND
ITS COMRADES ARE GOING TO DO THIS ANYWAY.
IT IS A DAILY STRUGGLE SLAPPING AN STICKING ALL
THAT THEY SEE.

STICKERWAR.NET WAS BUILT BY THESE TWO FOR
DOCUMENTING THE PROGRESS OF THE WAR AND
ALL OF ITS FREEDOM FIGHTERS. DONT GET
CONFUSED THEY ARE NOT WARING AGAINST OTHER
STICKER GROUPS SUCH AS STICKERNATION,
WOOSTER COLLECTIVE, EKO SYSTEM AND ANY OF
THE OTHER GROUPS WE ALL KNOW ABOUT. THEY
JUST STARTED .SW. BECAUSE OF THERE LOVE FOR
STICKERING, AND IN THIS MORDERN WORLD MAKING
WAR SEEMS TO BE THE WAY TO SHOW LOVE!

.SW. TRY TO DOCUMENT THINGS AS THEY HAPPEN
WETHER ITS DAILY OR WEEKLY. THE SITE IS
CONSTANTLY GROWING AND UNDER
CONSTRUCTION. NOTHING IS AUTOMATED,
EVERYTHING IS DONE MANUALLY.

.welcome to stickerwar.

.UNDER ATTACK.
.
.LONDON. MANCHESTER. PARIS. AMSTERDAM.
.ALLICANTE. UTRECHT. MAASTRICHT. ROTTERDAM.
.GRONINGEN. LEIDEN. DEN HAAG. GELEEN.
.SITTARD. MARSEILLE. CHEDDAR. GENK. ITALY.
.HAARLEM. STRASSBOURG. ST VITH. MELBOURNE.
.MEXICO CITY. ANTWERP. BROKELY. MILAN.
.ARNHEM. HILVERSUM. UTRECHT. LONDON.
.BRUSSEL. LES ARCS. ARNHEM. VALKENSWAARD.
.HILVERSUM. LEEDS. RENNES. BENIDORM. IBIZA.
.POLAND. VENRAAY. OLDENZAAL. SIMPELVELD.
.HEERLEN. AIX. EINDHOVEN. NIJMEGEN. ST.
.PETERSBURG. MOSCOW. SYDNEY.

T
H
E

A
R
T

O
F

R
E
B
E
L
L
I
O
N

(21) (65) (62)
(33) (158) (38)
(154) (254) (16)
(04) (24) (57)
(75) (456) (36)
(56) (48) (47)

WWW.STICKERWAR.NET

WOOSTERCOLLECTIVE
http://woostercollective.com/

Greetings from the Wooster Collective!
We launched the Wooster Collective website (www.woostercollective.com) in January of 2003 having absolutely no idea how quickly it would become so popular around the world. The response has been absolutely overwhelming. Prior to launching the website, we were huge fans of sites like Ekosystem and Stickernation, so now being recognized alongside them as one of the best websites for art is an incredible honor for us. Today, each month the Wooster site is read by tens of thousands of people from around the world. We've profiled hundreds of artists on the site who all share a common bond the passion for creating art for the street. Some of the most popular features on the Wooster site include: "Give 'Em Props" where we ask artists to pick that ONE painting, sculpture, or piece of architecture that truly inspires them in their daily work; "The Five Tips" where we ask artists to give us their five favorite tips; and "The Wooster Interview" where we ask artists fifteen essential questions. In the eight months since launching the Wooster site, we've actually never answered our own questions. So exclusive for you now, we thought we'd finally sit down over a nice bottle of Napa Cabernet and answer the same questions we've asked hundreds of artists from all over the world.
Here you go. Hope you enjoy it!

<div style="position: vertical; left-margin">T H E A R T O F R E B E L L I O N</div>

The Wooster Collective - The Vitals:

Age:
38 and 32. Yikes we're old!
(There are two main members of the Wooster Collective)
Hometowns:
Los Angeles, California and Winterport, Maine, two cities on the exact opposite ends of the United States.
Where do you now live?:
Soho, New York City (on Wooster Street, of course!)
How long have you been creating street art?:
2 years.
What did you do last night?:
Drank red wine with friends on a roof deck in Tribeca. Ate an amazing vegetarian sandwich at Tiny's Giant Sandwich Shop in the Lower East Side. Then walked the dog, Hudson, in the rain and went to bed.
What is your favorite thing to eat for dinner?:
Definitely sushi. Especially Negi-toro.
Who is your favorite fictional character?:
anesha.
What do you currently have in your pockets?:
An ipod that needs to be recharged. A Mobile phone with a dead battery. A plastic bag to clean up our dog's poop when we walk her later tonight. Some of Rep1's kick ass stickers. A flyer for our upcoming photography show in Brooklyn.
If you were given "more time," what would you do with it?:
Definitely sleep more. Create more art of course. Update the photo galleries on the Wooster website (www.woostercollective.com). Travel to more cities to meet more artists!
Who do you love?:
Ganesha

Wooster Collective - The A's to Our Q's:

Question: How did you get started in creating art for the street?:
Wooster: We moved to lower Manhattan a few years ago and were blown away by the incredible amount of amazing art we saw on the streets of our neighborhood. One weekend afternoon we decided to make a series of stickers by attaching interesting faces we found in magazines and affixing them to "HELLO MY NAME IS." stickers. Months later we realized that a photographer had taken a photograph of one of them. It was selected as part of the amazing STICK 'EM UP book from Booth-Clibborn.
Question: What other street artists do you most admire and why?
Wooster: That's a tough question for us answer! We've featured hundreds of artists on the Wooster site so we like them all. Part of the excitement of Wooster is the opportunity to continuously discover new artists.
But if you were to put a gun to our head and force us to choose it would have to be: Faile, Swoon, London Police, Flower Guy, Flying Fortress, Jon Burgerman, Mudwig Dan, So Fuzzy Crew, and Dan Witz.
Question: What's your favorite city, neighborhood, or block, to post and/or to see street art?
Wooster: Our neighborhood, Soho in Lower Manhattan, is one of the best places in the world for street art. In New York, we also love the check out the Lower East Side and the East Village. In Europe we love the east end of London and the incredible art that's under the bridge at St Eriksbron in Stockholm.
Question: What inspires you now?
Wooster: The new art we find on the street each day truly inspires us. So does the art that's sent to us via email each day from around the world.

FIVE TIPS FROM THE WOOSTER COLLECTIVE

1.. Hang up your towels after you use them following a shower.
2.. Next day's cold pizza makes a fantastic breakfast!
3.. When you go out at night wheat pasting, take a dog along with you. It's more fun and the cops won't both you.
4.. Invest in a digital camera. It'll change your life.
5.. Costa Rica is a great place for a cheap vacation.

GIVE 'EM PROPS:

a little knowledge can go a long way
a lot of professionals are crackpots
a man can't know what it is to be a mother
a name means a lot just by itself
a positive attitude means all the difference in the world
a relaxed man is not necessarily a better man
a sense of timing is the mark of genius
a sincere effort is all you can ask
a single event can have infinitely many interpretations
a solid home base builds a sense of self
a strong sense of duty imprisons you
absolute submission can be a form of freedom
abstraction is a type of decadence
abuse of power comes as no surprise
action causes more trouble than thought
alienation produces eccentrics or revolutionaries
all things are delicately interconnected
ambition is just as dangerous as complacency
ambivalence can ruin your life
an elite is inevitable
anger or hate can be a useful motivating force
animalism is perfectly healthy
any surplus is immoral
anything is a legitimate area of investigation
artificial desires are despoiling the earth
at times inactivity is preferable to mindless functioning
at times your unconsciousness is truer than your conscious mind
automation is deadly

Jenny Holzer's "Truisms" are a daily inspiration to us on so many different levels. As an artist, Jenny uses only text - without any images - to produce incredible emotions. Each word, so carefully chosen, reveals our inner thoughts. The text, ften about sex, crime, and love, peaks into the core of human nature. So much of today's street art can be traced back to Jenny Holzer. She was one of the first and remains to this day to be one of the best.

Starring: Dave the Chimp, Mysterious AL, PMH, D-Face, Kabe, Ichy, Ronzo, Flying Fortress, Saru, Tron, Product 2, Dist, Crooked Industries, Jake, Matt Sewell, Schucks, Charlie, Solo One, Tizer, Blam, Lady Blush, Anubus.

THE ART OF REBELLION

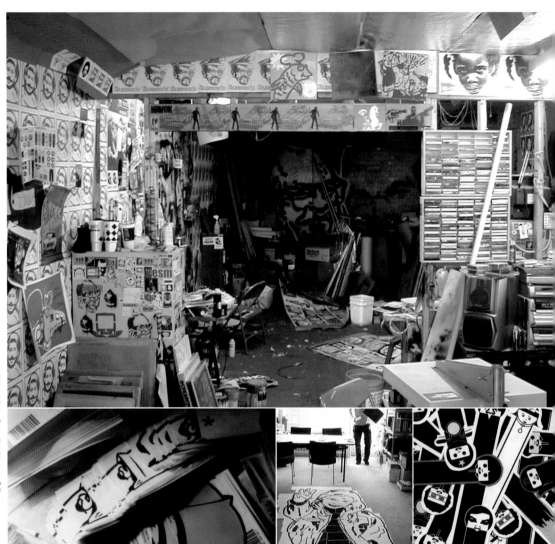

clockwise: ACAMONCHI, EKO, SPACE3, FLYING FORTRESS
below l-r: ABOVE, D-FACE, INVADER

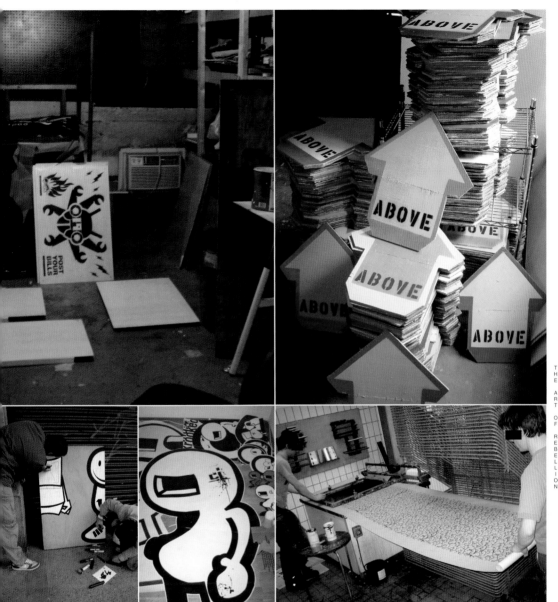

clockwise: W/REMOTE, ABOVE, GOMES, CROOKED INDUSTRIES, THE LONDON POLICE & D-FACE
below l-r: WORK PROCESS BY SUPAKITCH

THE ART OF URBAN WARFARE

http://www.aouw.org/

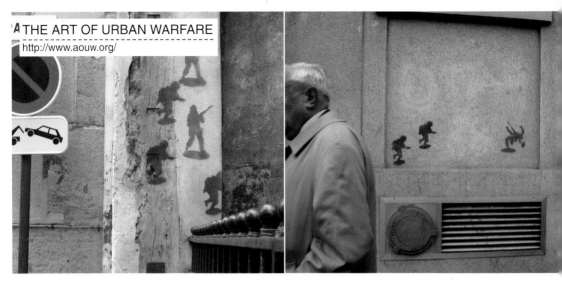

Here is a description of our project 'liefde'.
On the cd you will find some photographs and a response to your questions.

'liefde' (Love) is a collection of positive words tagged on the zebra crossings in Amsterdam.
With this project we wanted to spread a positive feeling. The words such as happiness,
love, kiss, please, confront you with your own emotions and have a positive impact. Feeling
good starts with yourself.

Good luck with your Book.

INVISIBLE CITIES

http://www.toyshopcollective.com/

INDIVISIBLE CITIES: DESCRIPTION

indivisible cities is a visual and cultural exchange focusing on artistic interventions in the urban landscape. creating itself out of the margins of our cities is a community of people, more precisely it is a community of actions, a floating world of ephemera and physical markings made by people who have decided to become active citizens in creating their visual landscape. everytime someone reappropriates a billboard for his or her own needs, scrawls their alias across a highway overpass, or uses city walls as a sounding board for their thoughts and images - for messages that need realization, they are participating in this community. they are circumscribing a link to every other person who believes that the vitality of our public spaces is directly related to the public participating in the incessant creation and re-creation of those spaces. we are proposing a way for this community to connect and grow without regard for physical or geographical borders. through the cooperation of people in different locations all over the world who are willing to participate by executing projects sent to them, and who would like to see their own impulses carried out on the streets of cities they may have never even seen. you do not need to have a background in street art, you do not even need to be an artist, all you need is an idea about creation in public spaces. each person who contributes a project will receive a project to carry out in return. you will then need to document the finished product and send the photo back to us. the documentation will be posted on the indivisible cities website where each artist can reconnect with their work and see how it has been translated through the hands of another person in another place. from aug 22nd through the end of september 2003, the documentation will be exhibited in berlin as a part of the "back-jumps: the live issue" this is just one stop-over-point, indivisible cities will be an ongoing project. for info go to www.toyshopcollective.com

fadings
graffiti to design, illustration and more
05.2005
isbn: 3- 3-980-9909-0-7
s. schlee
hardcover, 28x21cm, 240 pages

straight lines
ecb reso | a ten year graffiti-art dialog
03.2004
isbn: 3-980-7478-5-9
p. jungfleisch, h. beikirch
hardcover, 15x21cm, 128 pages

stylefile.blackbook.sessions.#02
graffiti on paper. scribbles, outlines
and full-color-stuff
04.2004
isbn: 3-980-7478-8-3
m. christl

power of style – berlin stylewriting
trains, walls and sketches all over berlin
05.2003
isbn: 3-980-7478-3-2
true2thegame
hardcover, 24x17cm, 128 pages

hamburgcity.graffiti
all about graff in hamburg
10.2003
isbn: 3-980-7478-6-7
typoholics
hardcover, 21x27cm, 176 pages

stylefile.graffiti.magazine
out every march, july and november
documenting in high quality the graffiti- and streetart-movement all over the planet

for details and further informations check www.stylefile.de

publikat verlags- und handels KG
hauptstr. 204
d-63814 mainaschaff
germany
www.stylefile.de
info@stylefile.de

THE ART OF REBELLION 2

**RELEASE DATE:
FALL 2005**

SOON!